UXBRIDGE
THROUGH TIME
Ken Pearce

Sincere good wishes,

Ken Pearce

AMBERLEY PUBLISHING

This document, dating from about 1180, gave the people of Uxbridge the right to hold a market every Thursday.

First published 2011

Amberley Publishing
The Hill, Stroud
Gloucestershire, GL5 4EP

www.amberley-books.com

ISBN 978 1 4456 0522 7

British Library Cataloguing in Publication Data.
A catalogue record for this book is available from the British Library.

Typeset in 9.5pt on 12pt Celeste.
Typesetting by Amberley Publishing.
Printed in the UK.

Introduction

In 1985 an advertisement appeared in Uxbridge for a new office block to be called Wixan House. Sadly the name was never used, but the evidence points to a Saxon tribe called the Wixan settling by the River Colne in about the eighth century. In due course they put a bridge across the river – the Wixan Bridge – and this appears to be the origin of the name Uxbridge.

The river settlement was small, but in the twelfth century a new town was laid out on higher ground, where we find Uxbridge town centre today. In about 1180, the people of this new town were granted the right to hold a market every Thursday (see frontispiece).

The market town flourished, with corn as the main commodity. The nearby flour mills on the Colne and the Fray's enabled the corn to be processed locally. By 1800 Uxbridge was one of the largest corn markets in the south of England. At this period stagecoach traffic reached its peak, with eighty coaches a day passing along Uxbridge High Street. The town's economy was further boosted by the completion of the Grand Junction Canal in 1805. Timber, slate, coal and locally produced bricks and tiles were transported on the canal.

The opening of the Great Western Railway in 1838 changed everything. The main line ran about two miles to the south of Uxbridge, and soon the new, smooth method of travel was preferred to the slow, uncomfortable stage coach. That trade rapidly diminished. Farmers and growers also found that market-gardening and fruit-growing were now more profitable than corn. Uxbridge market declined in importance, despite the fact that the town was at last connected to the GWR by a branch line in 1856.

The year 1904 proved very significant. Electric cars of the London United Tramways arrived from Shepherds Bush, and the Metropolitan Railway was extended to Uxbridge. London was sprawling out, and the Uxbridge area became an outer London suburb.

In 1917 the Hillingdon House estate on the outskirts of the town became the Armament and Gunnery School of the Royal Flying Corps, and in 1918 the service was re-named the Royal Air Force. In the Second World War an underground operations room in the station was the control centre for our fighter aircraft in the Battle of Britain. RAF Uxbridge closed in 2010.

Since the war Brunel University has developed to the south of the town on former horticultural land.

In recent times, because Uxbridge is close to Heathrow Airport and the M4, M25 and M40 motorways, it has become a desirable place for firms to have their headquarters. Modern office blocks have sprung up everywhere. The following pages reveal that the town has been largely rebuilt in the last eighty years.

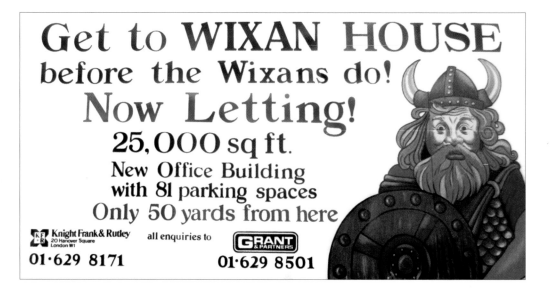

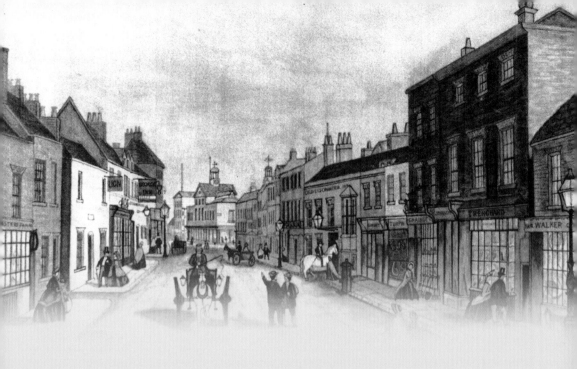

CHAPTER 1

The Main Street

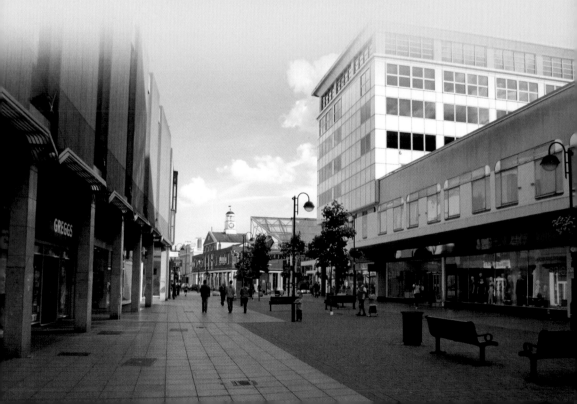

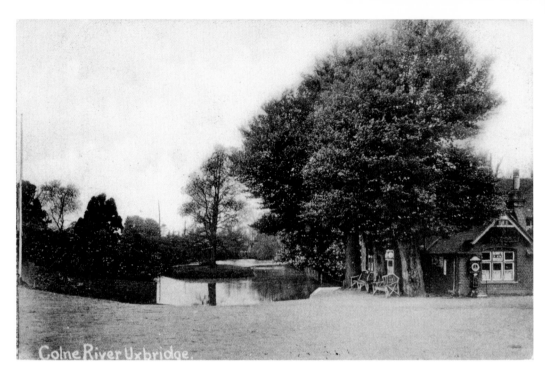

Where It All Began

It was here by the river Colne that the Wixan tribe settled in Saxon times. On the right is the Swan & Bottle public house, which was in existence by 1761, and remains popular today.

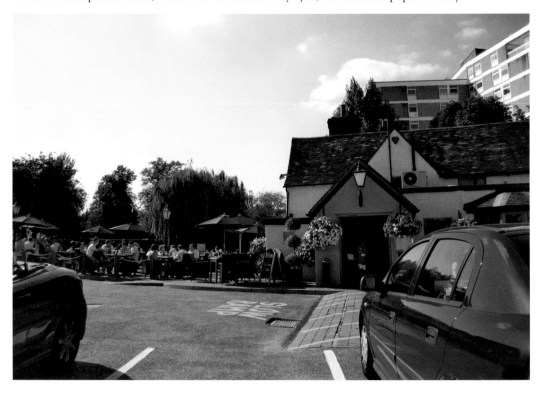

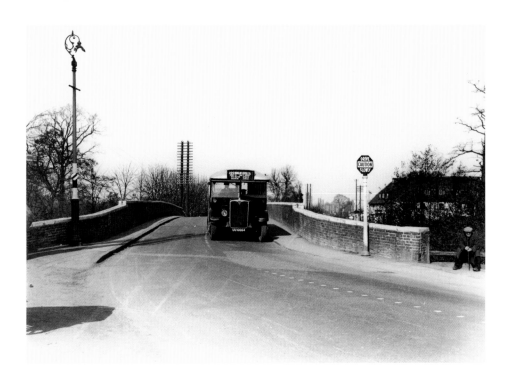

High Bridge
A bus is seen entering Uxbridge from Denham in 1935. This is the site of the original Wixan Bridge, which gave the town its name. Both this bridge and the nearby canal bridge were rebuilt in 1938.

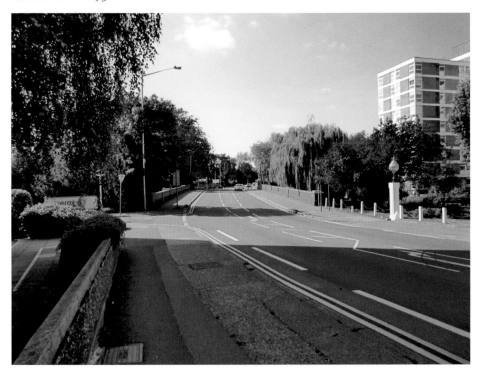

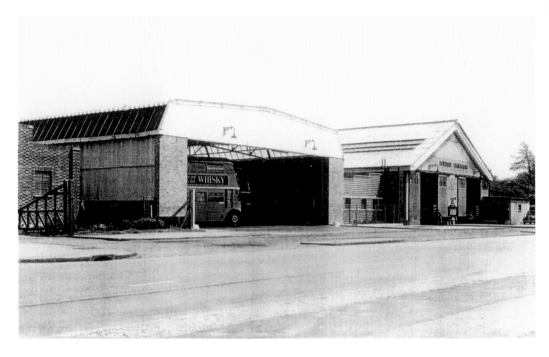

Uxbridge Bus Garage
The garage stood in Oxford Road, Denham, and was opened in 1921. A second building was added about 1950. The buses moved to the Bakers Court basement in 1983, and the ICM office block was built on the site.

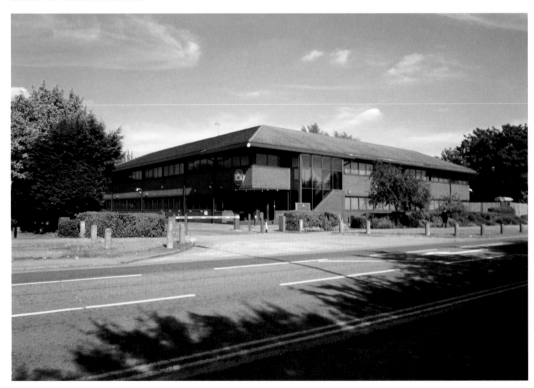

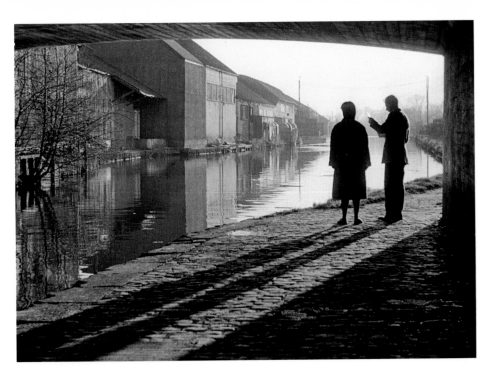

View Under the Canal Bridge

Looking south under the bridge near the Swan & Bottle in 1960 we see on the left the extensive canal-side timber yards dating from the end of the eighteenth century. Today they are being replaced by office buildings.

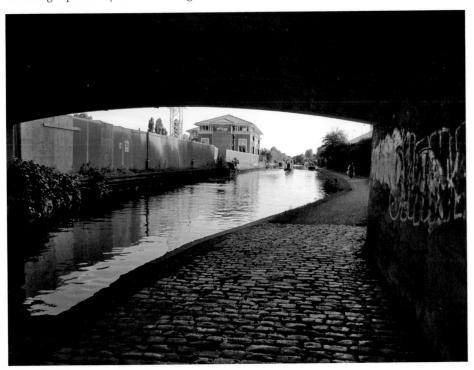

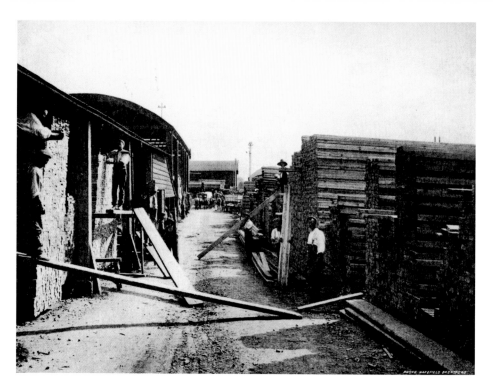

Timber Yards

The main yard of Osborne, Stevens & Co., about 1900. At its peak the firm employed 250 people on a 26-acre site, but the business closed in 1966. Since then the Highbridge industrial estate has emerged there, with hi-tech offices in landscaped surroundings.

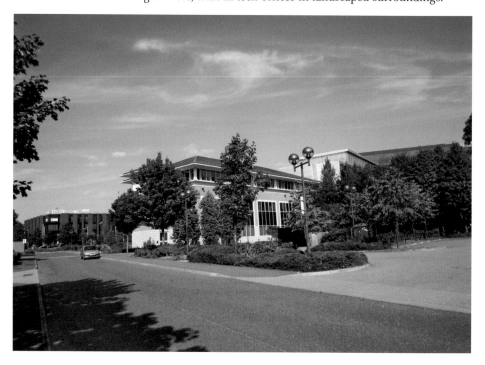

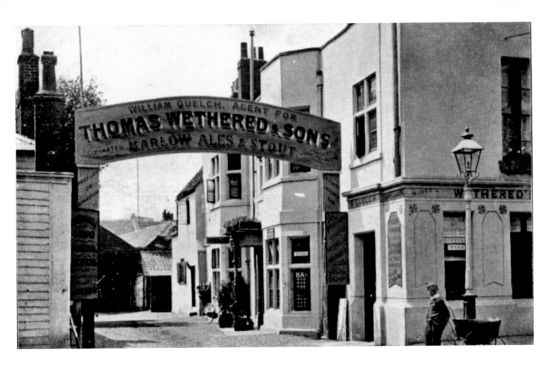

The Crown & Treaty

This building is the west wing of what was at one time the largest private house in Uxbridge. In 1645 unsuccessful talks were held here in an attempt to halt the Civil War. No treaty was signed. After the canal was cut through, the property became a public house.

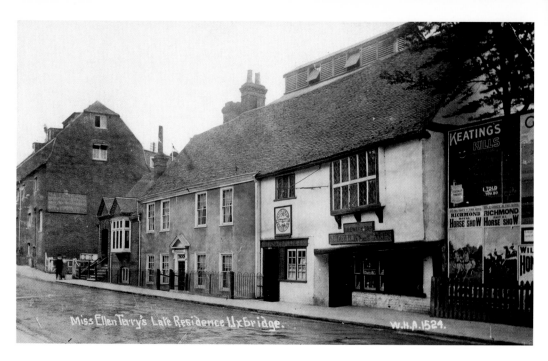

Ellen Terry's Cottage

The house next to the advertisements was rented by the actress Ellen Terry as a weekend retreat in the 1880s. Beyond it is Fountain's Mill, a former corn mill severely damaged by fire in 1954. What remains is now a Youth Centre.

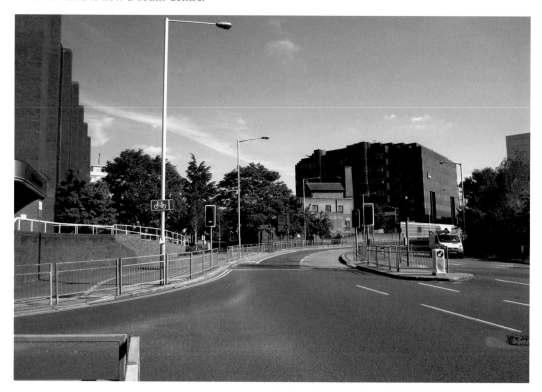

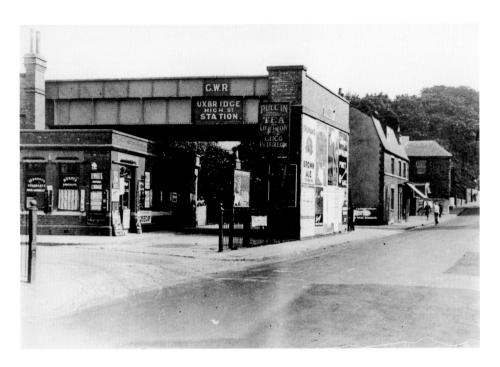

High Street Station

On the left we glimpse the GWR station opened in 1907, a branch line from the main line at Denham. It was at first hoped to link the line with the other branch at Vine Street, but the company realised that it would never make any money. The branch finally closed in 1964. In the lower picture the building on the left is the Nursing Faculty of the Buckinghamshire New University.

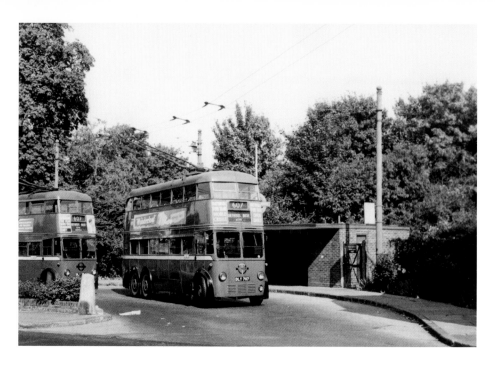

Trolleybus Terminus

In November 1936 the old trams were replaced by trolleybuses, and London Transport obtained a site opposite Fountain's Mill as a terminus. The trolleybuses ran until 1960. The site of the former terminus is now occupied by an apartment block called Riverbank Point and incorporates a restaurant.

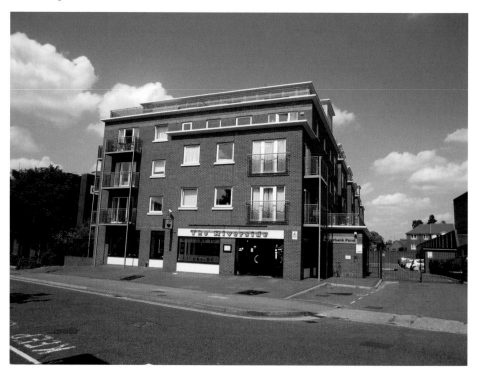

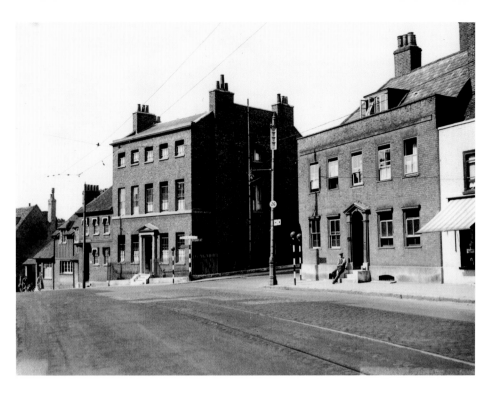

High Street and Harefield Road
The narrow entrance to Harefield Road in 1936. The decision had just been taken to demolish the large house on the far side to widen the road; this took place in 1938.

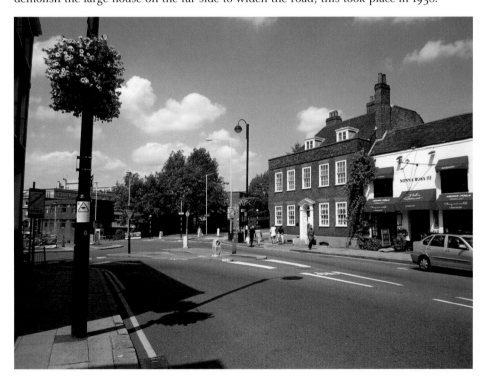

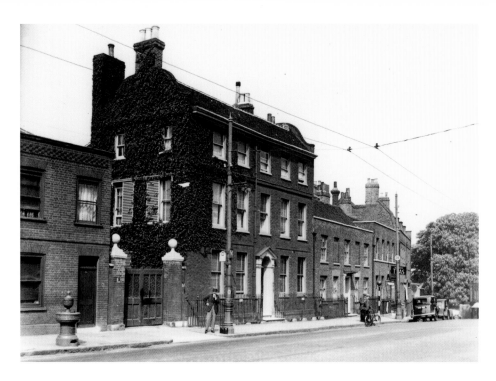

The Cedars

The large house was for many years the home of the Fassnidge family, local builders. The last family member to live there was Mrs Kate Fassnidge. On her death in 1950 she left the house and garden to the town. The garden was destroyed in a town development scheme in the 1960s, a grand act of civic vandalism.

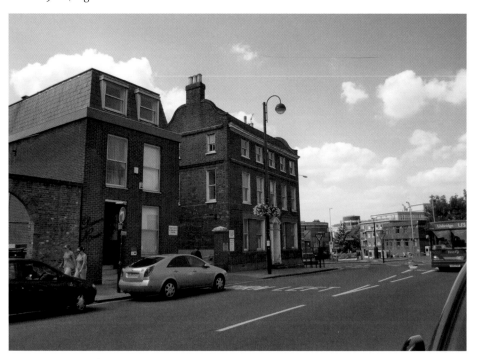

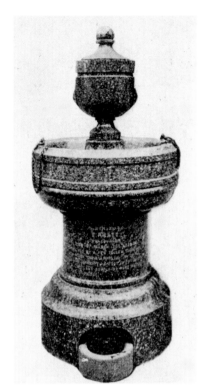

Pratt Memorial Fountain

Visible in the previous picture is the drinking fountain
erected in 1901 in memory of a local engineer named
Edward Pratt. He campaigned for a constant supply of
piped water for the town, and it was achieved on the very
day he died! The remains of the fountain can be found
today in the garden at the lower end of Windsor Street.

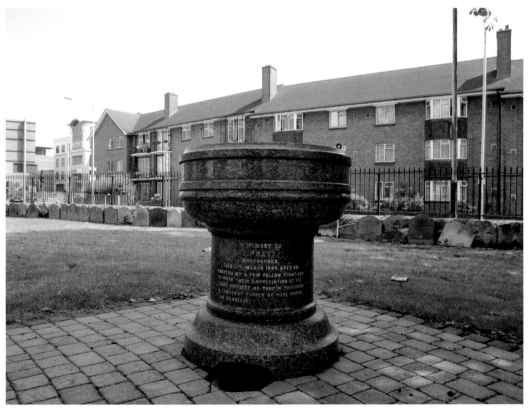

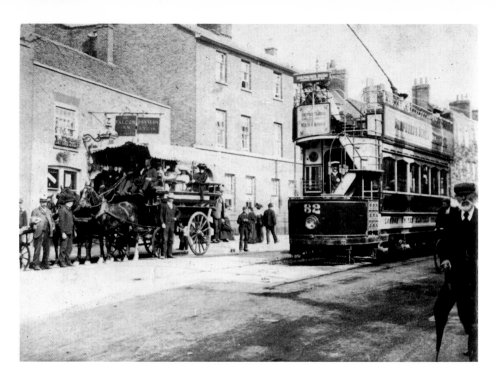

Tram Terminus

Electric trams ran through to Uxbridge for the first time on 31 May 1904. One of those early open-topped trams is shown here at the terminus and on the left you can see a horse-bus ready to take passengers to Denham. The last tram ran on 14 November 1936.

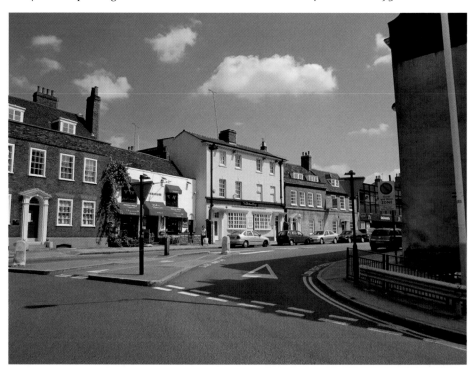

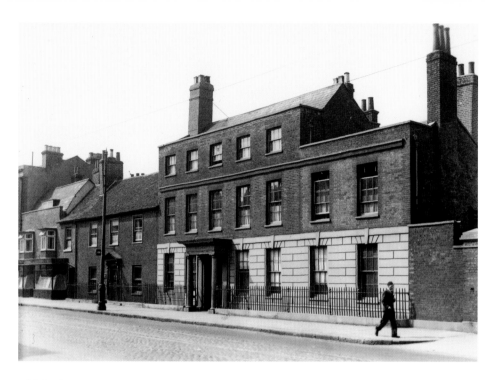

Old Bank House

Uxbridge Bank was founded in this building in 1791 by two local businessmen, Daniel Norton and Nicholas Mercer. The bank moved to the corner of Belmont Road in 1866, and was taken over by Barclays in 1900. This building later became a private house and then the offices of a solicitor. The NHS now occupies most of the building.

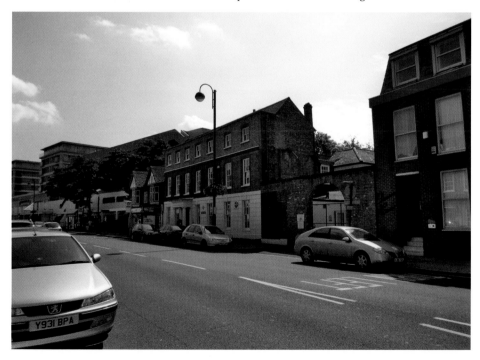

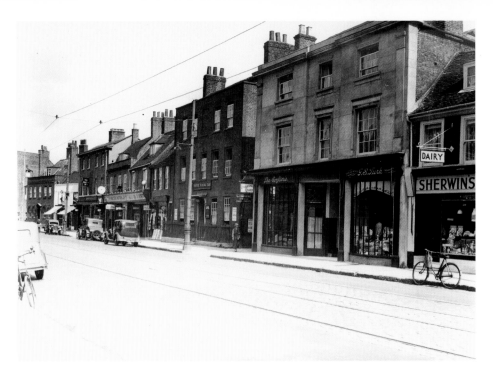

Nos 118 to 127 High Street

This section of the main street has not changed much since the top photograph was taken in 1935. One building was demolished in 1970, and its replacement houses McDonald's restaurant. Next to it is the narrow entrance into Beasley's Yard.

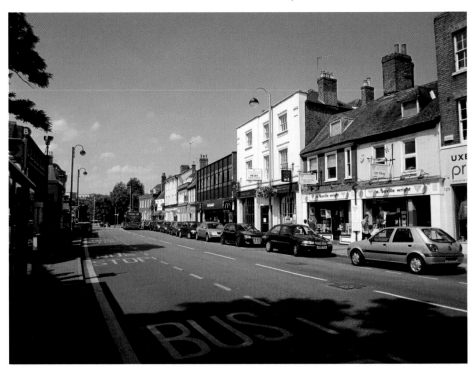

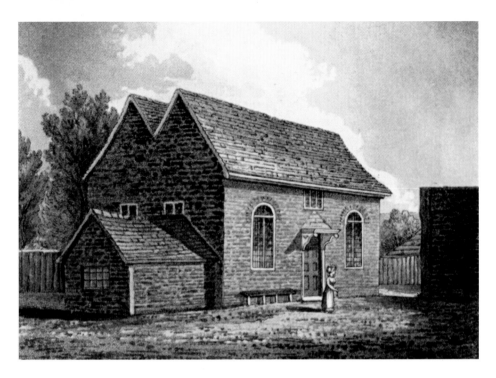

Old Meeting House, 1818

This Congregational chapel was built in 1716, and enlarged in 1883. It remained a place of worship until 1972. Since then it has become a church hall for Christ Church, and was renamed Watts Hall in memory of the hymn-writer Isaac Watts. It stands in Beasley's Yard, named after a former minister of the chapel.

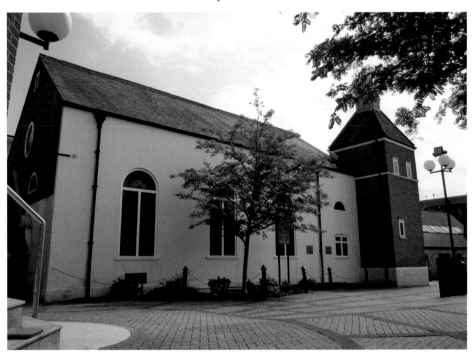

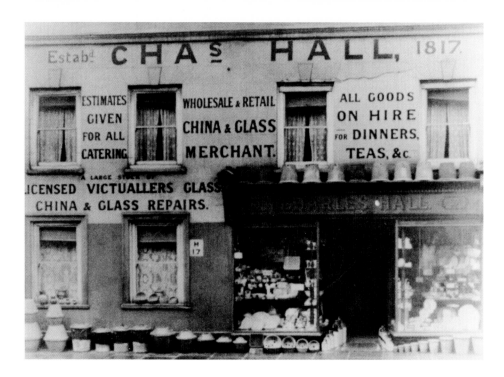

Hall's China Shop

This business was established in Windsor Street in 1817, and moved to this site at 51 High Street in 1883. It was run by three generations of the Hall family, all with the first name Charles. The shop closed when the third Charles Hall died in February 1947. The Tesco store was opened there in 1979 by comedian Ronnie Corbett.

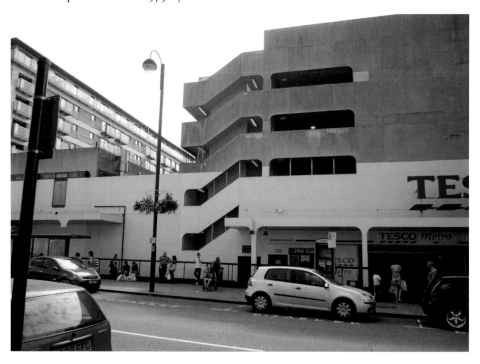

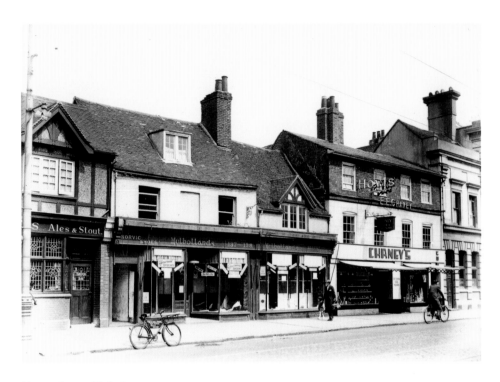

Nos 136–140 High Street

In this 1935 photograph part of the Crown & Sceptre public house can be seen on the left and Barclays Bank on the right. While they remain today, rebuilding has taken place between them.

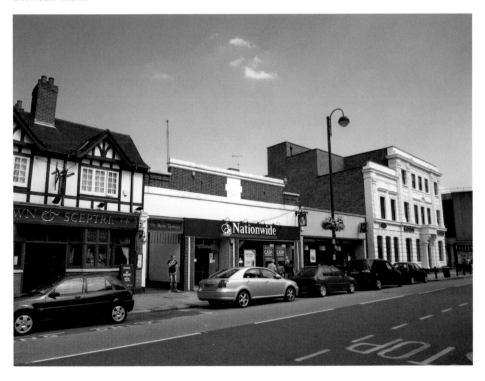

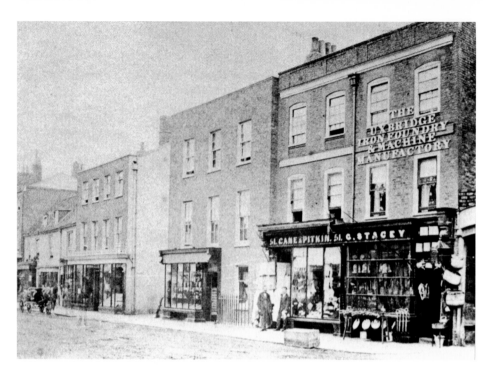

Opposite Belmont Road
A glimpse of the High Street about 1880 reveals the premises of an ironmonger, draper, tailor, linen draper, cutler, builder and undertaker, hairdresser and stationer. The street was not properly surfaced until 1902.

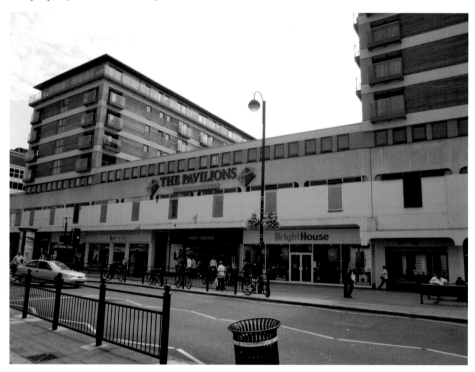

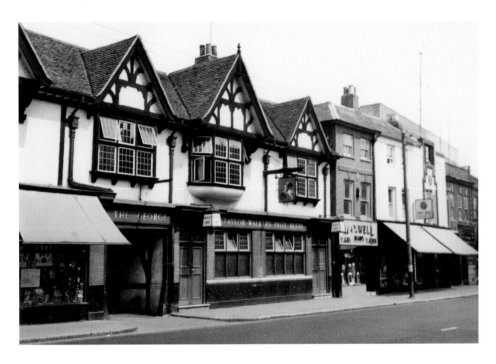

The George Hotel

This was one of the old coaching inns of Uxbridge, with a yard that once led to extensive stables and outbuildings. The frontage was completely reshaped in 1936 to the design of local architect W. L. Eves. This photograph was taken just before the inn closed in 1960. Following demolition eleven years later the shopping parade below replaced it.

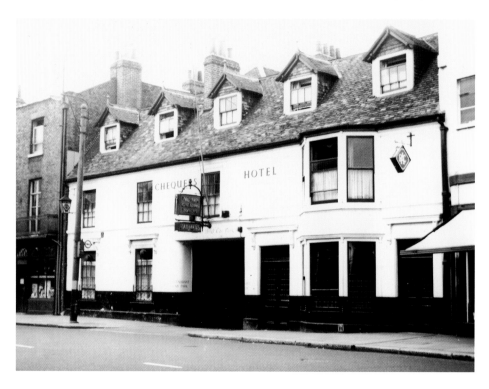

The Chequers Hotel
Another of the town's inns that flourished in the stagecoach era. In 1908 the USA marathon runners in the London Olympics stayed here (see also page 53). The inn closed in 1960, but the name survives in Chequers Square, part of the Mall Pavilions shopping centre.

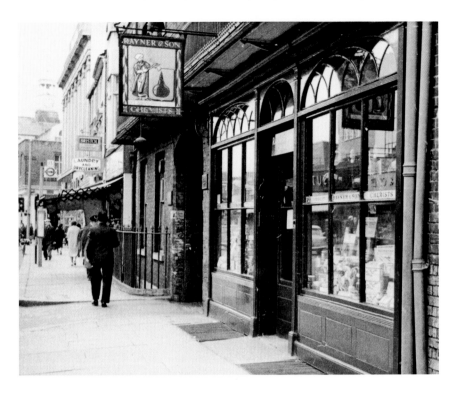

Rayner's the Chemist's

Next to the Chequers was the elegant shopfront of Rayner's – an old fashioned chemist's, with carboys containing coloured liquid on display in the windows. Modern deodorants could be found on shelves still labelled 'Horse and cattle medicines'. The shop closed in 1962.

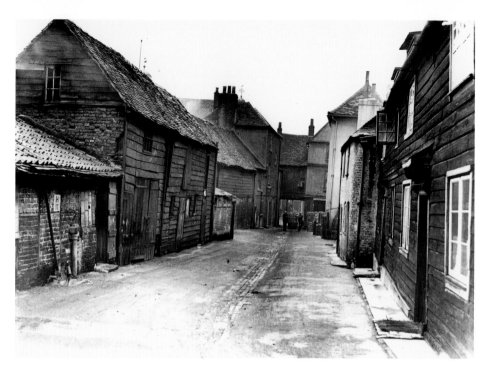

Baker's Yard

The yard takes its name from James Baker, who ran a china shop here in the early nineteenth century. In 1901 there were sixty-seven people living in cottages in this yard. All were swept away in the mid-1930s, when a new underground station was built on one side, and gas company headquarters on the other.

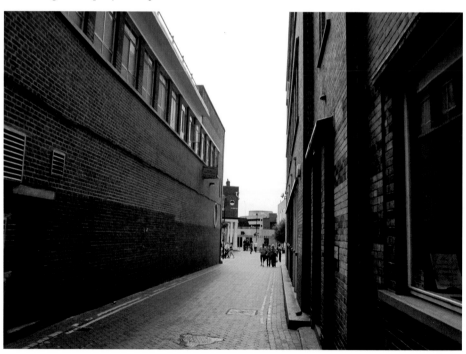

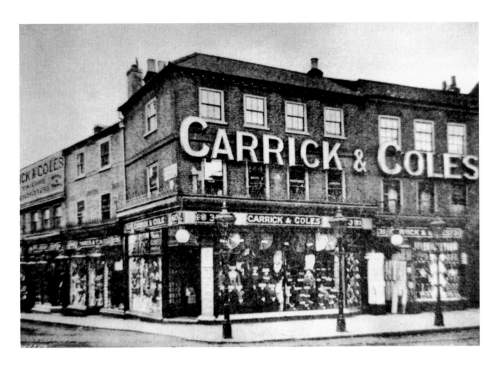

Carrick & Coles

This large draper's shop was opened in 1849 on the corner of High Street and Windsor Street, and was run on the lines of *Are You Being Served?* A firm called Suter's ran the shop from 1924 to 1936, after which a new building was erected there (see page 50). This also went in 1973, when the shopping precinct arrived.

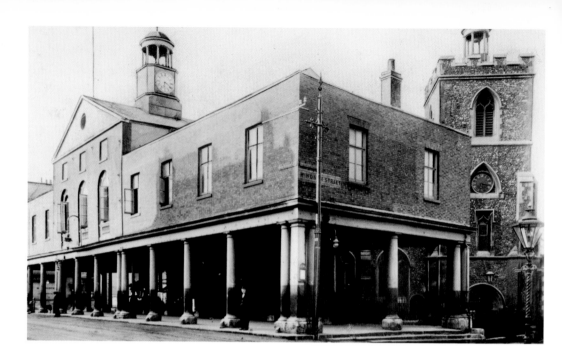

The Market House

The building stands as a symbol of the town's history, for Uxbridge was a market town for centuries. Erected in 1789, it replaced an earlier and smaller building. In 2011 much of the building was empty, as though seeking a new identity.

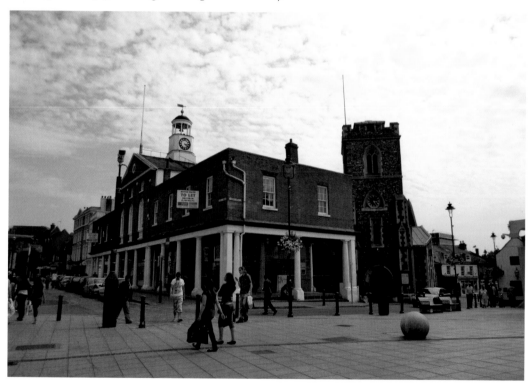

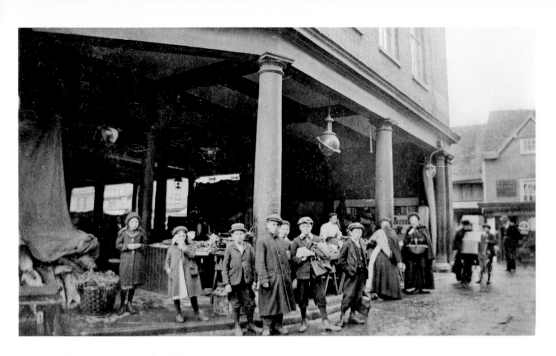

Market House, South Side

The scene dates from about 1910, when stalls were set up daily on trestle tables on the ground floor. Everyone, including children, wore hats at this period. This is where the earlier market house stood, erected in the sixteenth century.

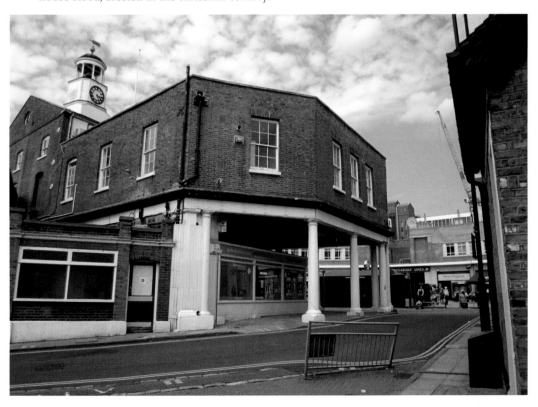

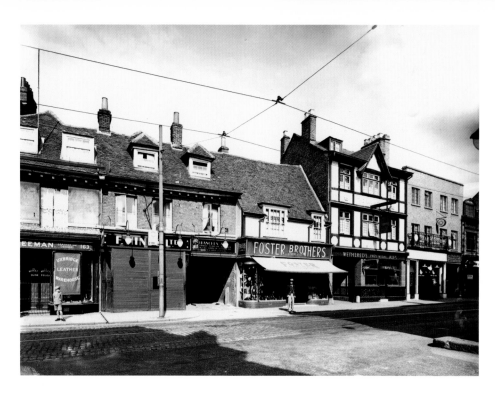

Opposite the Market House

These are the shops that were demolished in 1936 to make way for the new underground station. Most of the firms moved to other sites in the town, but MacFisheries and Timothy White's moved into the station frontage.

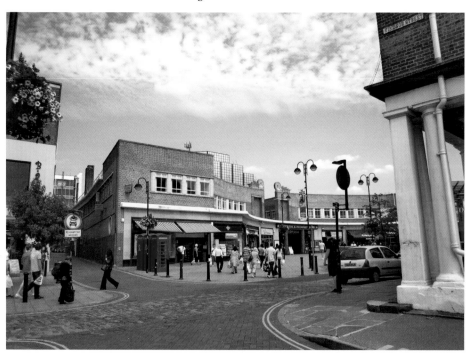

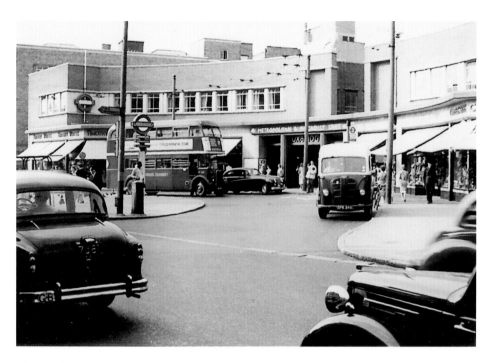

The Station Forecourt

The new station, opened in 1938, was set back from the road giving space for this forecourt. Traffic, including buses, was able to pull in to the station entrance. Pedestrianisation led to the whole area being paved.

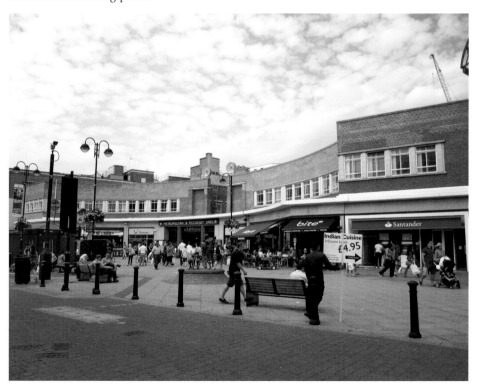

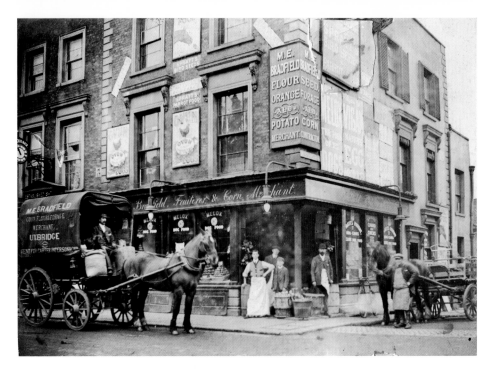

Bradfield's

On the corner of the High Street and Windsor Street stood the store of Charles Bradfield, a corn, flour and seed merchant who also sold fruit, vegetables and pet foods. In 1921 the premises were taken over by the Midland Bank, now known as HSBC.

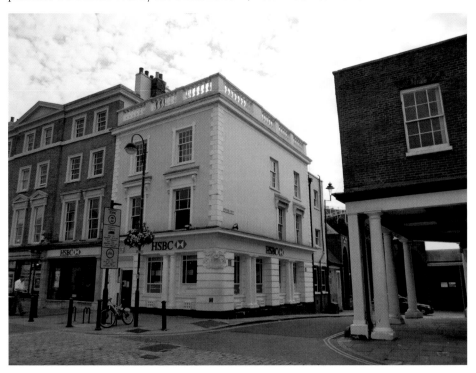

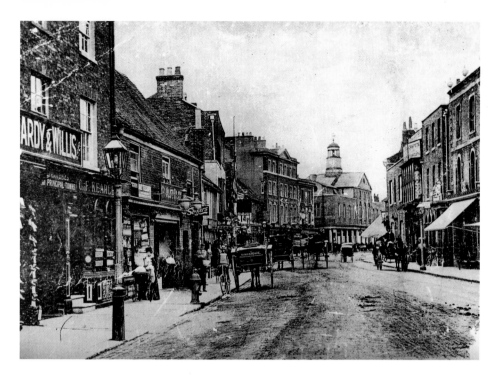

Market House Area

A look at the old market town about 1909, before a proper surface was put on the High Street. Lighting was by gas, the motor car had yet to appear, and there were no chain stores in the town. This section of the main street was pedestrianised in 1985.

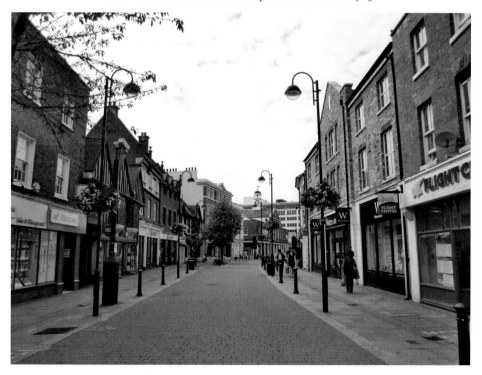

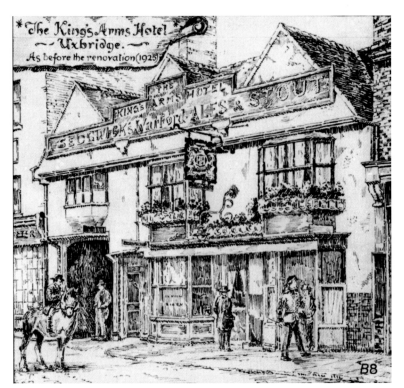

Kings Arms Hotel
The drawing shows another of the town's coaching inns, with its gabled frontage and oriel window over the yard entrance. The inn closed in 1960, and the premises were later adapted to become office accommodation.

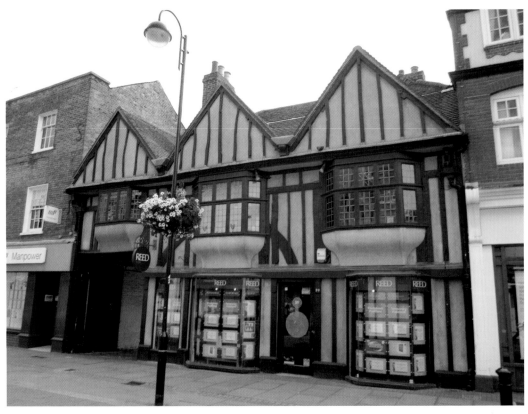

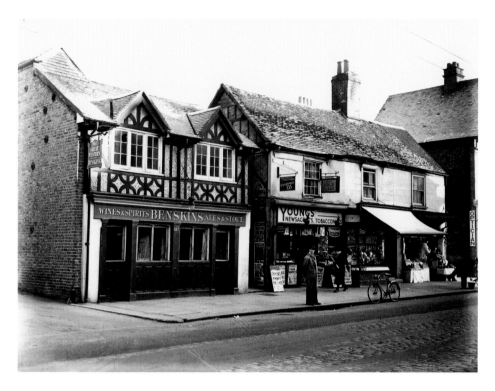

Shops near George Street
The 1940 photograph shows the Great Western public house on the left, which had just closed. The timber-framed building on the right housed three shops, and survived until 1973.

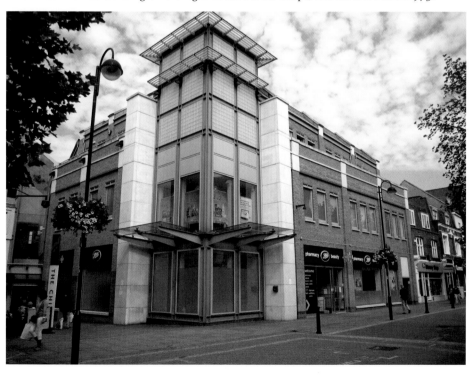

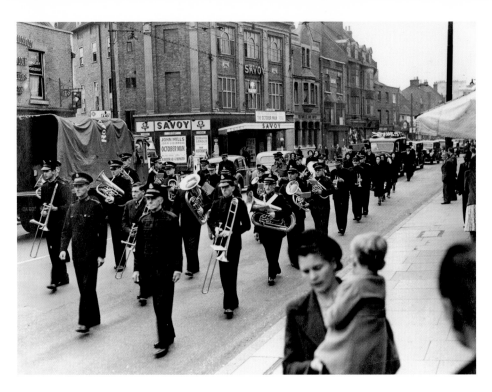

The Savoy Cinema

This cinema opened in 1921 on the corner of the High Street and Vine Street, and closed in 1960. The photograph dates from 1947, when the funeral of a prominent Salvation Army member was passing by. The Royal Bank of Scotland occupied a new building here in 1987.

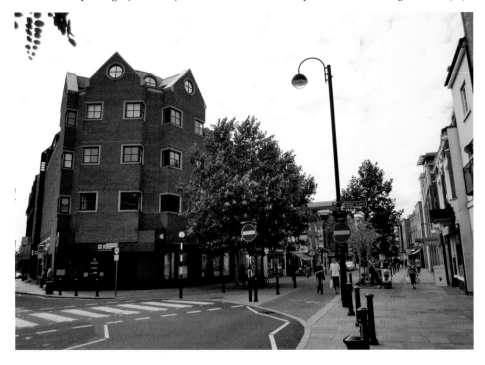

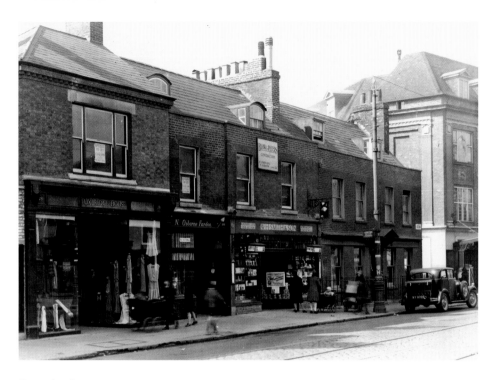

Near the Savoy

This 1930 view reveals the then narrow entrance into Vine Street, with the cinema in the background. The building to the right of WHSmith was a doctor's surgery, and was demolished in 1936 to permit road widening.

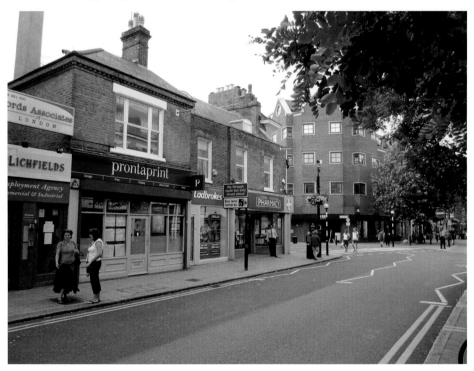

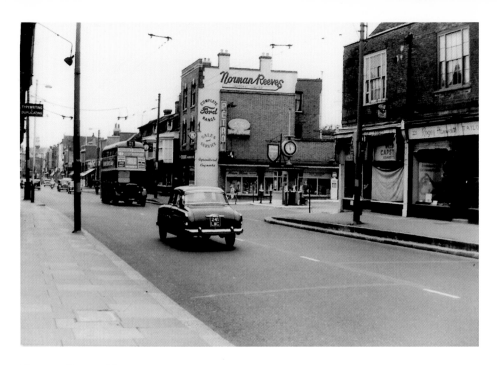

Norman Reeves Motors

The showrooms of the car firm Norman Reeves are prominent among these shops at the south-eastern end of the High Street. Their premises were opened here in November 1939, and the firm remained until 1983.

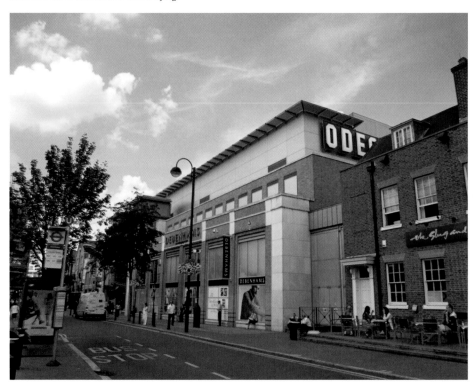

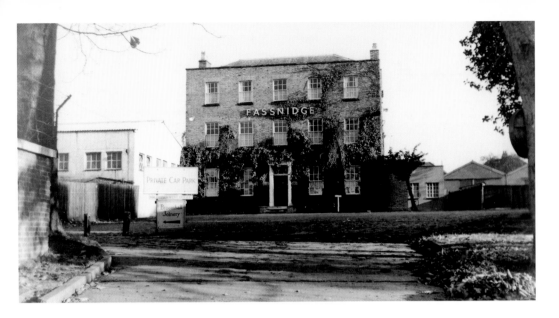

The Shrubbery

This house was built about 1835 by Thomas Walford, a local solicitor, and remained a residential property until 1950. It then became the headquarters of the building firm Fassnidge, Son & Norris, until they left the town in 1990. The property was kept as part of the Chimes development, and has been a Pizza Express restaurant since 2001.

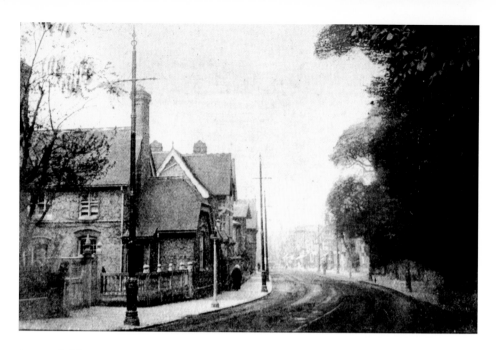

Dragonfield

This residence, on the left, was built about 1870 by Charles Roberts, an Uxbridge doctor. From 1911 to 1915 it was occupied by Cecil J. Sharp, an authority on English folk-song and dance. From 1935 the building housed various council departments, but was cleared away after a fire in 1973. The Civic Centre was then erected nearby.

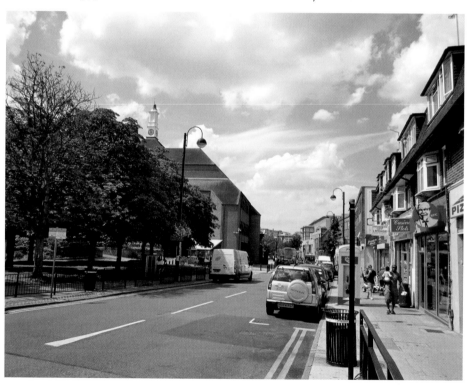

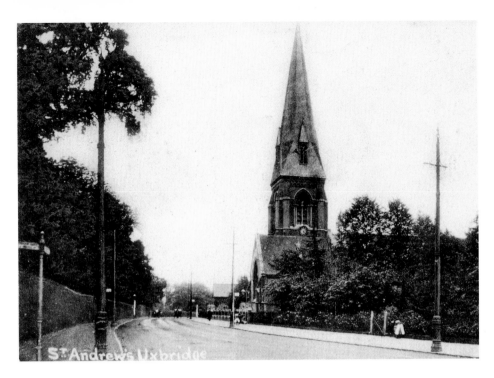

St Andrew's Church

As the population on the outskirts of Uxbridge grew in the nineteenth century, a new Anglican parish was created and named Hillingdon West. The parish church was designed by Sir George Gilbert Scott, and was consecrated in May 1865.

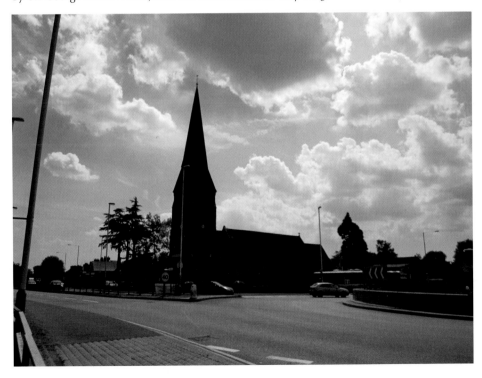

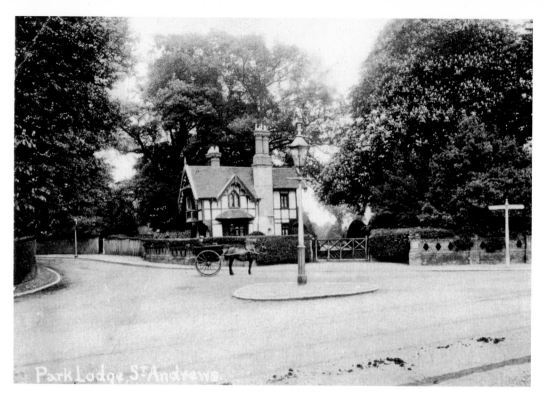

Park Lodge

The lodge and entrance gate to the Hillingdon House estate, where the High Street met Park Road. In 1917 the estate became the home of the Armament and Gunnery School of the Royal Flying Corps, soon to be re-named the Royal Air Force. Note the bombs on the gate pillars in the picture below.

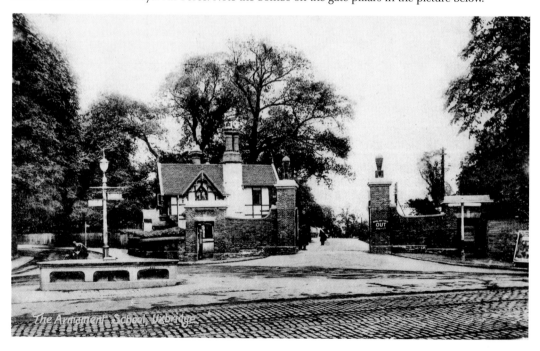

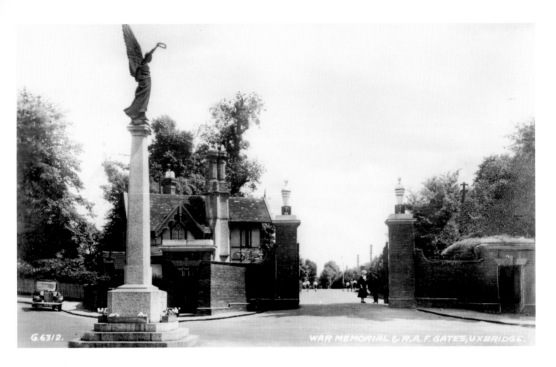

G.63/2. WAR MEMORIAL & R.A.F. GATES, UXBRIDGE.

Park Lodge
The same scene in the 1930s. The town's war memorial, on the left, was unveiled in 1924, and in 1972 moved to Windsor Street (see page 56). Below is the St Andrew's Gate, an impressive entrance opened in1957, but the departure of the RAF leaves its future uncertain.

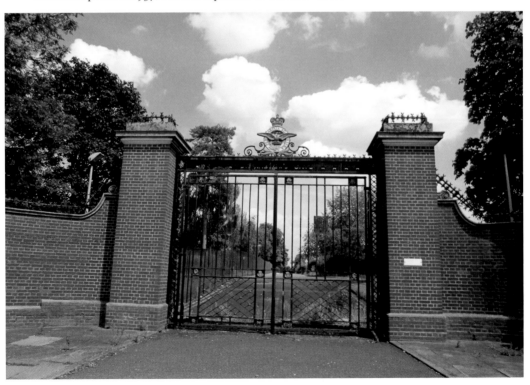

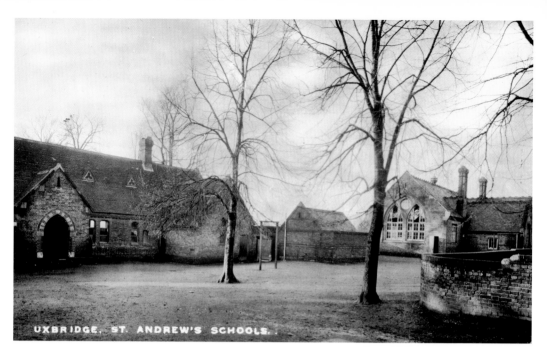

UXBRIDGE, ST. ANDREW'S SCHOOLS.

St Andrew's School
The church school, opened in 1869 as a girls' and infants' school initially, was enlarged in 1894. Town redevelopment brought the closure of these buildings, and below is the new school, which was opened in 1972.

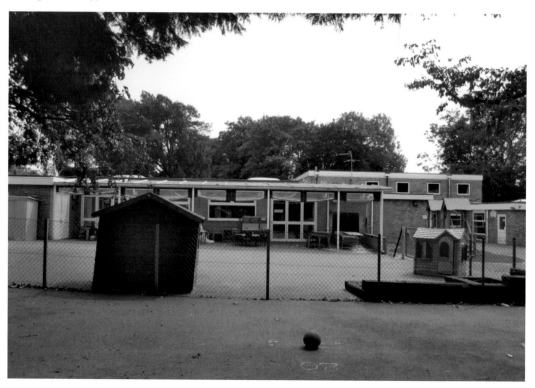

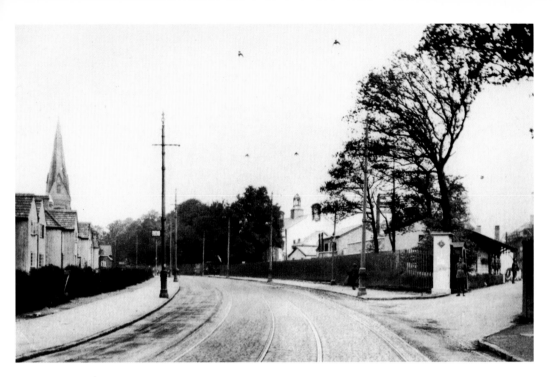

RAF Gate, Hillingdon Road
The main entrance to RAF Uxbridge as it appeared about 1930. The turret of the camp cinema can be seen in the background. Defence cuts brought the closure of the station in April 2010, and redevelopment is pending.

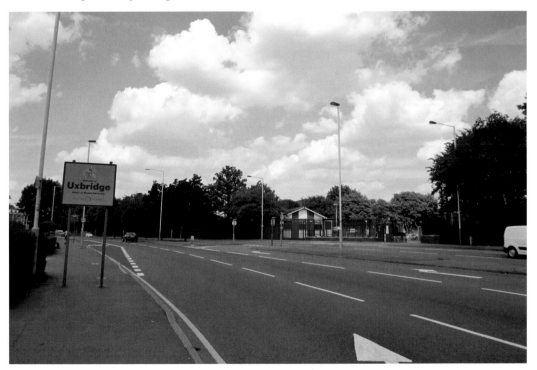

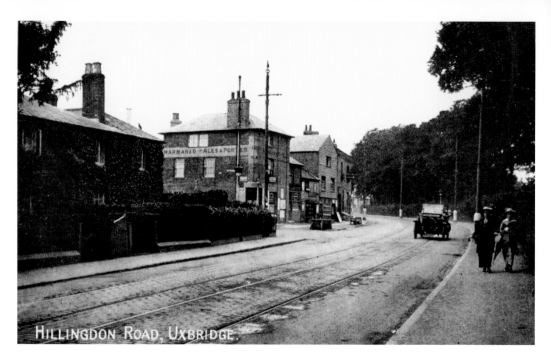

Hillingdon Road

The Green Man public house stood at the junction of the main road and the Greenway in about 1920. An all-night service for carters and carriers was offered here in the days of horse-drawn traffic. It shut its doors in 1995, and soon reopened as Jack's fish and chip shop.

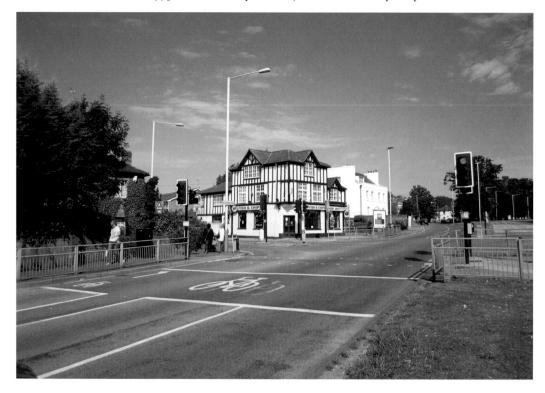

CHAPTER 2

Windsor Street

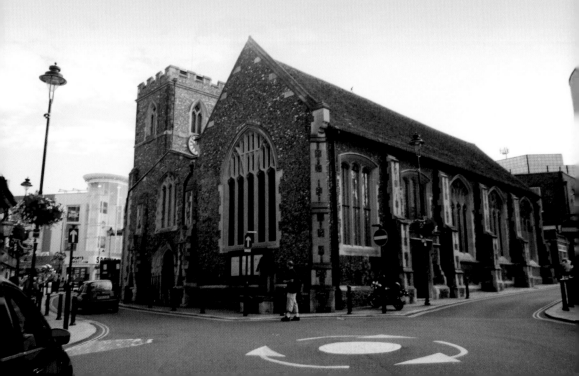

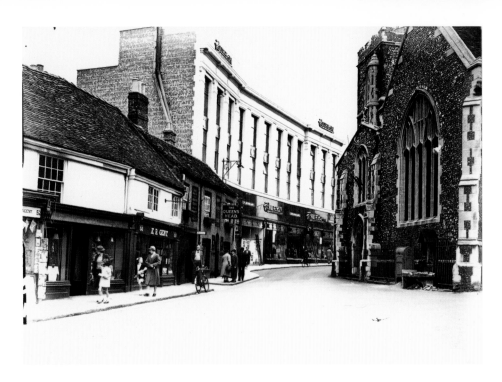

Burton's Building

The large structure in the centre was opened in 1938 for the tailoring company Montague Burton. On the upper floor was a dance hall that gained a certain notoriety in the period during and after the Second World War. It was taken down in 1972.

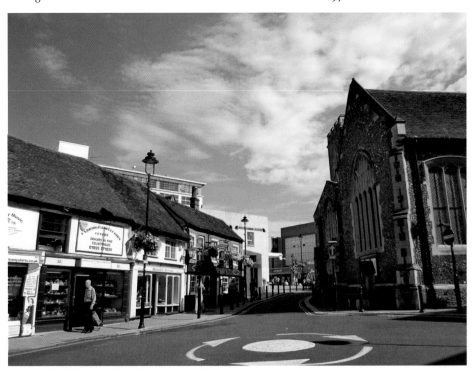

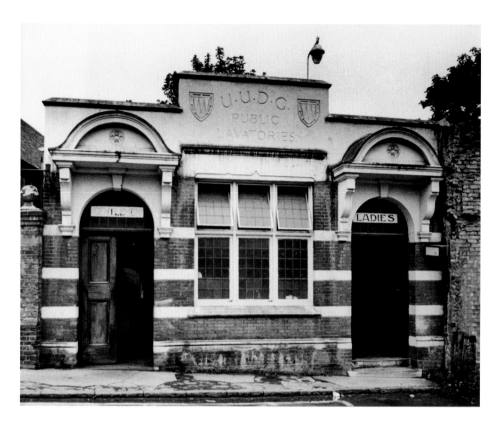

Public Lavatories

This convenience was opened by the Uxbridge Urban District Council in 1929 – a great relief to local inhabitants who had waited a long time for adequate facilities. The Charter Place development led to its removal in 1983.

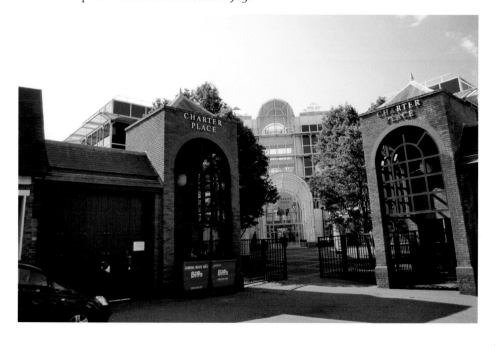

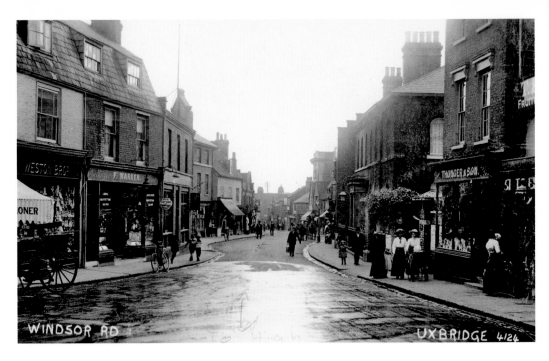

The Street, Looking South

The scene was taken from St Margaret's church about 1912, when the street was one of the main shopping areas of the town. The photographer has captured a busy centre in the days before traffic congestion.

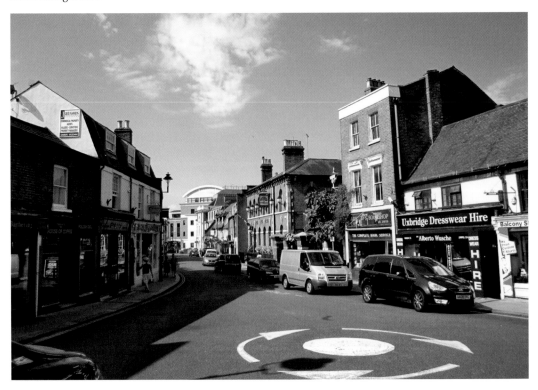

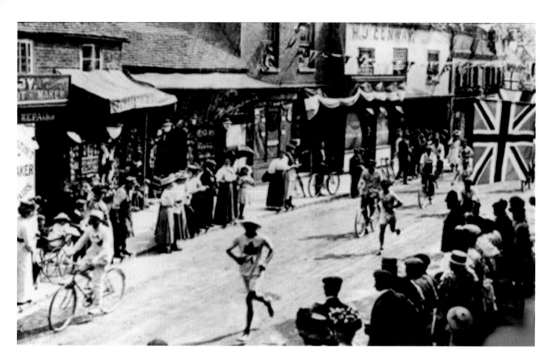

Olympic Events

In 1908 and 1948 the Olympic Games were held in London. On 24 July 1908 runners in the marathon race came through Windsor Street on their way to the White City. On 29 July 1948 the Olympic torch was carried through on its way to Wembley Stadium.

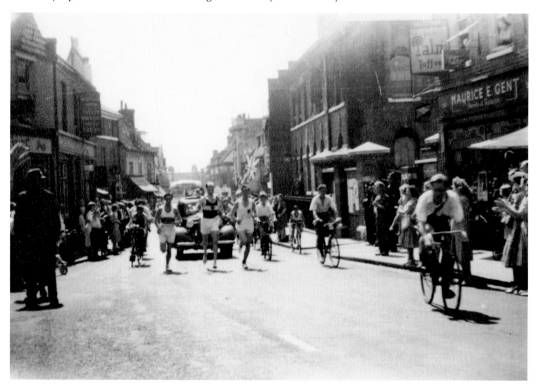

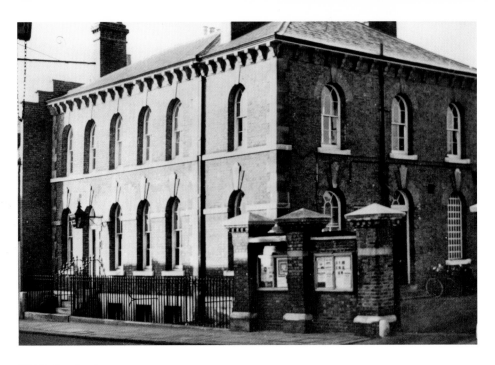

Old Police Station

In 1871 this building became the headquarters of the Metropolitan Police in the Uxbridge area. It closed in 1988, when a new centre was ready in Harefield Road. In 1996 the building re-opened as The Old Bill restaurant, and in 2006 it became The Fig Tree.

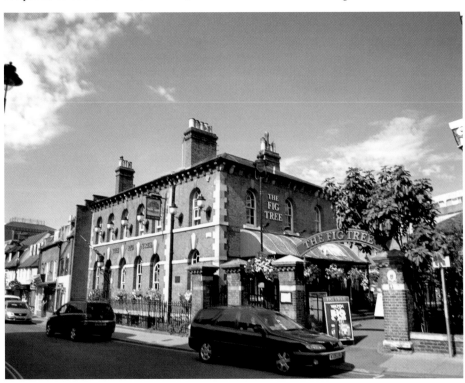

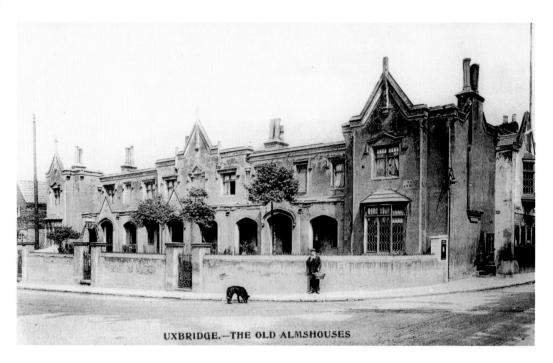

UXBRIDGE.—THE OLD ALMSHOUSES

Old Almshouses

Opened in 1845, these buildings provided eight homes for the elderly and needy residents of the town. New almshouses were provided in 1908, and in the following year the building below opened as the town's post office. Royal Mail left in 1990, and the building was altered and enlarged as office accommodation.

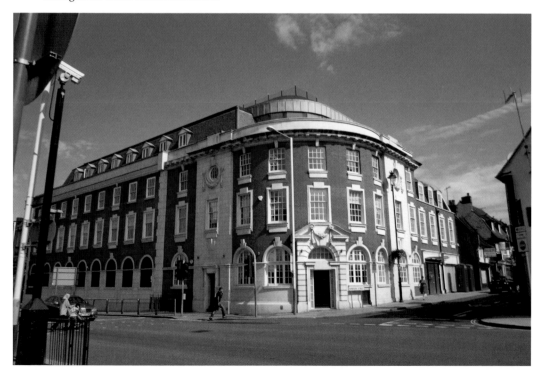

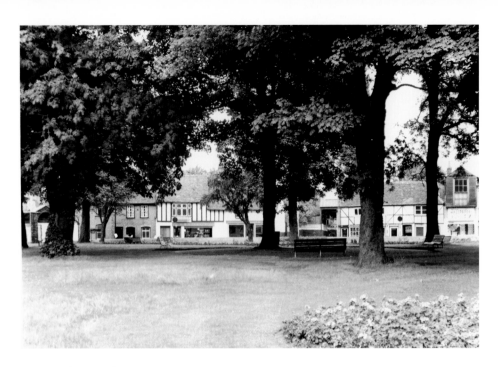

Old Burial Ground
This area was the town's cemetery from 1576 until 1855. Since then it has been converted into a pleasant garden in an otherwise crowded town. It is now the home of the Uxbridge war memorial. The Cross Street cottages in the background were demolished in 1969.

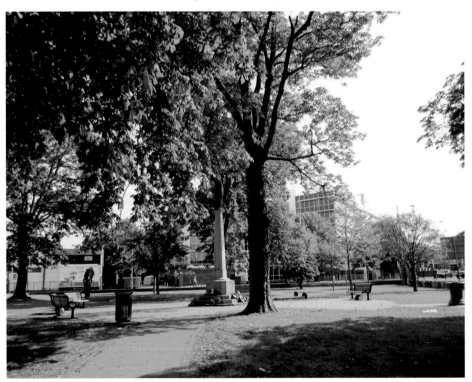

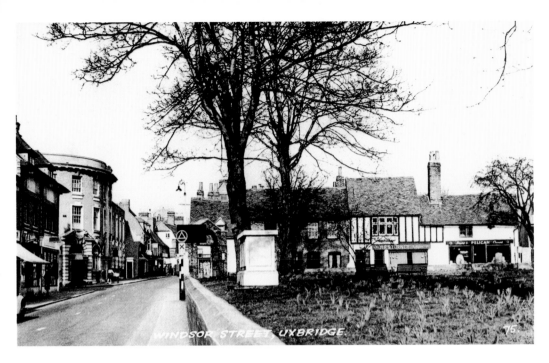

The Southern End

A scene from the 1950s showing the lower end of Windsor Street and part of the former burial ground. In 1970 Windsor Street was sliced in two by the creation of a new road, part of what local people call (unofficially) the Mahjack's roundabout.

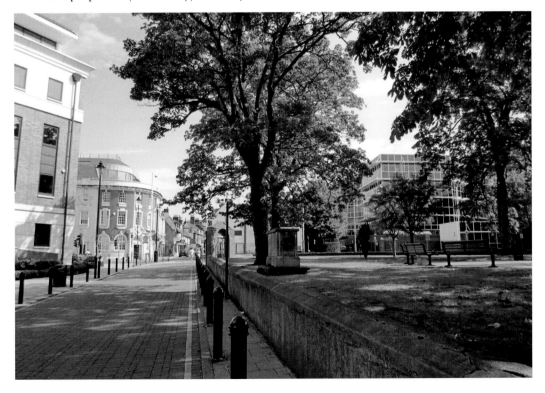

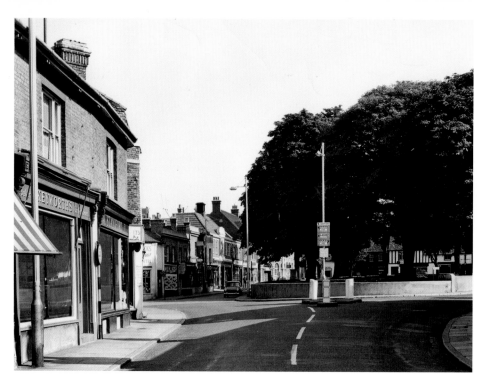

From Cowley Road

Another view of the south end of the street in 1962. Mahjack's DIY store can just be seen on the left, but the chestnut trees dominate the scene.

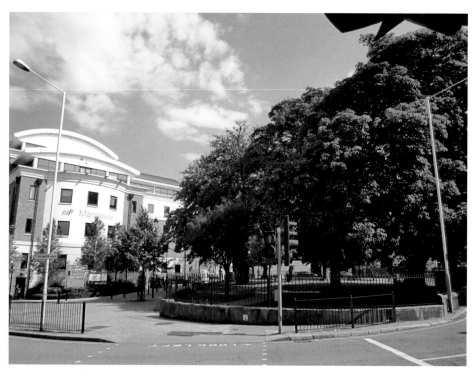

CHAPTER 3

Vine Street

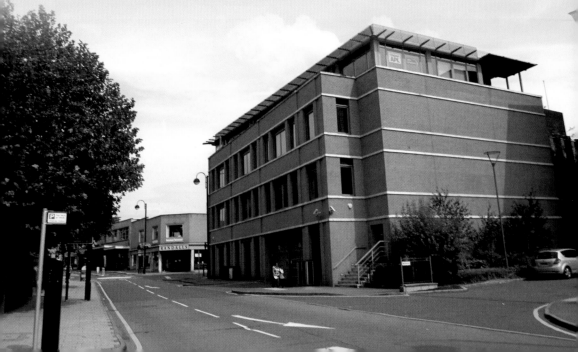

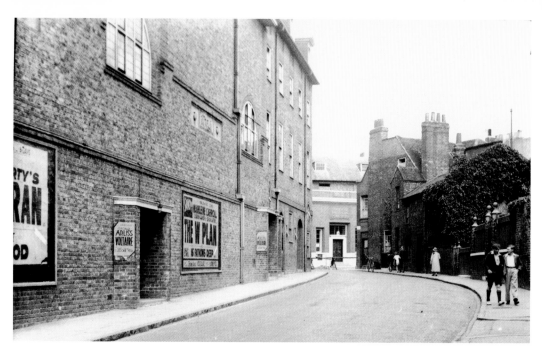

High Street End

In 1934 the side wall of the Savoy cinema is on the left, and a doctor's surgery at the end on the right. (See also page 39). In the gap we glimpse the front of the National Provincial Bank in the High Street.

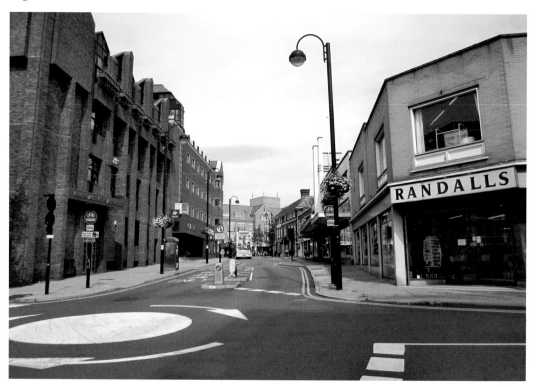

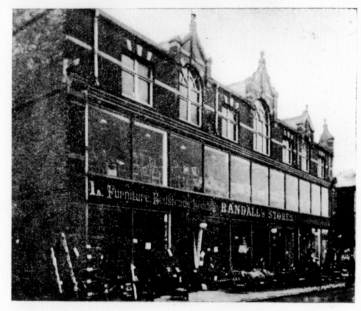

Complete House Furnishers.

Bedsteads,
Bedding,
Carpets,
Easy Chairs,
Suites in
great
variety.

Electric Car stops within half a minute, at Corner of Street.

Randall's Stores

The brothers William and Philip Randall came to Uxbridge in 1891, and took over a small furniture store. The business flourished, and the shop above came into use in 1900. That in turn was replaced by the present store in 1939.

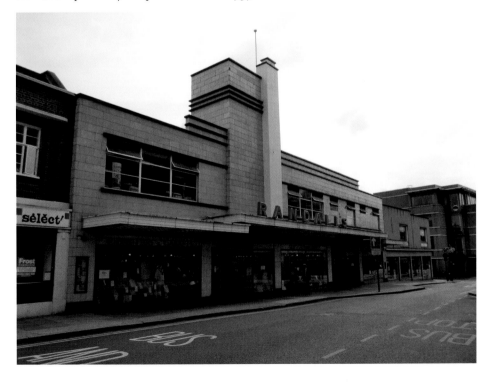

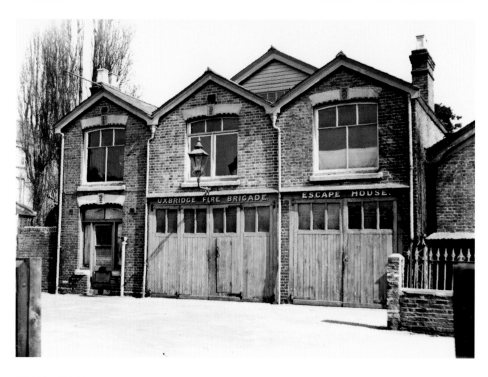

Old Fire Station I

This building was erected in 1908 as the headquarters of Uxbridge Fire Brigade. They moved out in 1933, but the structure survives as part of Randall's stores.

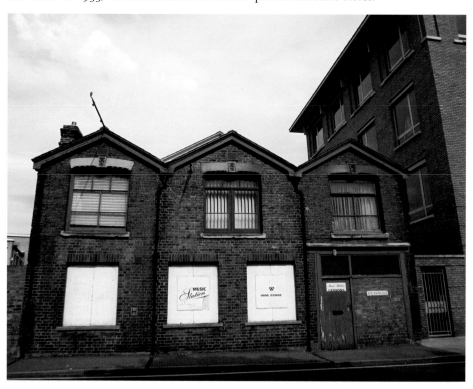

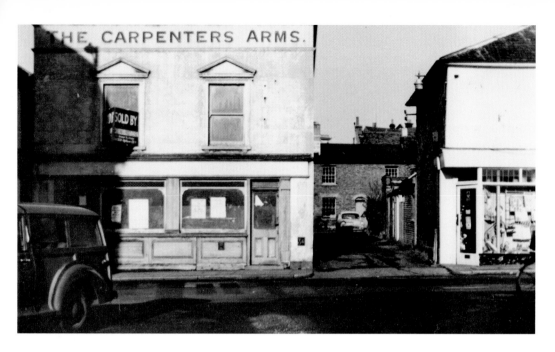

Carpenters' Arms

This beerhouse opened in about 1856, and survived for almost a century. To the right is a yard leading to a group of cottages called Janes Place. The site was cleared in the 1980s to make way for the Charter Place development.

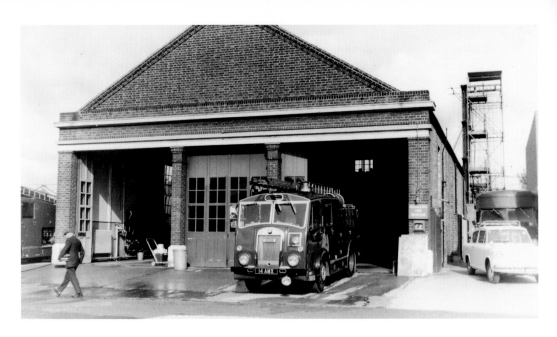

Old Fire Station II

In 1910 this edifice opened as the Empire cinema. After its closure in 1932 it was purchased by Uxbridge Council, and converted into a fire station. The brigade moved to Hillingdon in 1964, after which the building became a youth workshop for a time.

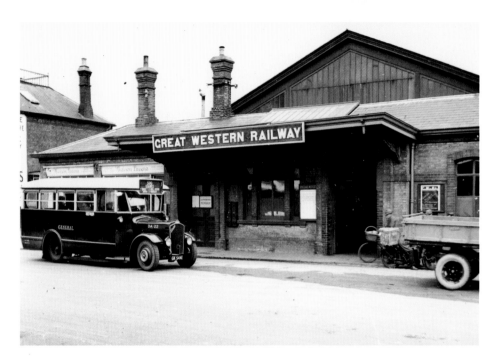

Railway Station

In September 1856 the first GWR train steamed into this station, the terminus of a branch from the main line at West Drayton. The above picture dates from 1931. The 'Beeching Axe' saw the end of passenger trains on the branch line in 1962, and goods traffic in 1964. The station was demolished in the following year.

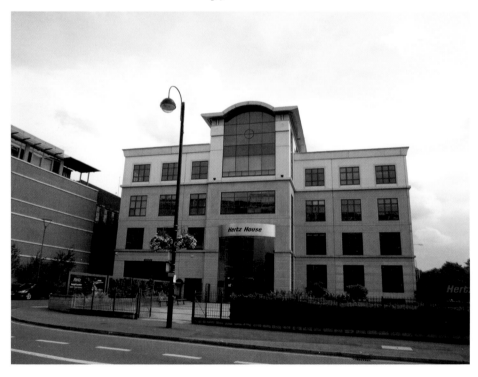

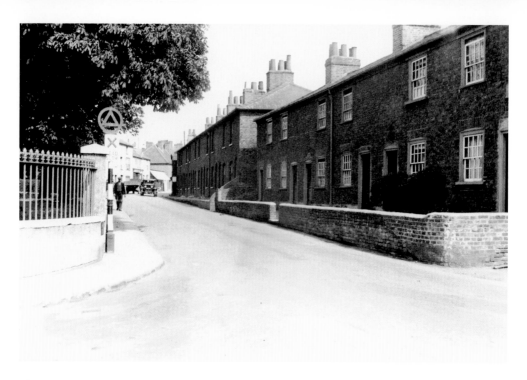

Vine Street Terrace

The nineteen cottages on the right were built in 1821, and faced the burial ground. They were replaced in 1958 by Cochrane House, a block of thirty-three flats built for the Borough of Uxbridge. The street was widened at the same time.

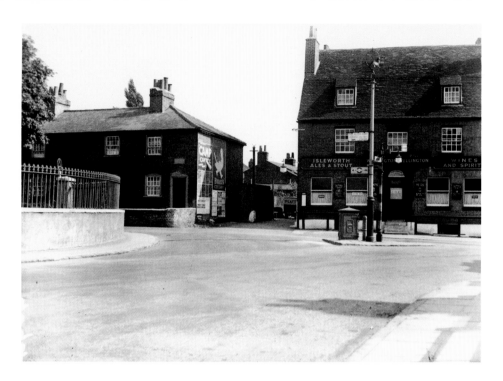

The Wellington

This public house, on the right, was opened in 1830, and named in honour of the victor of Waterloo. In 1934 Ackland's Yard was situated between the pub and the cottages. Ackland's were in the rag-and-bone trade, now called recycling. The present office block is called Wellington House.

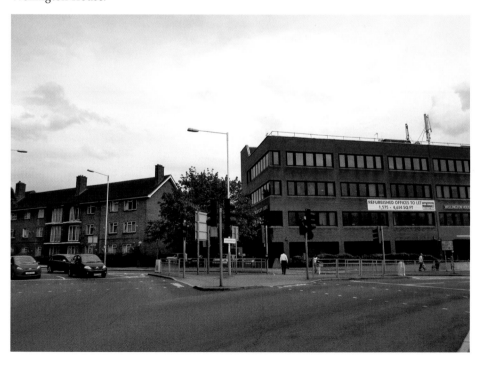

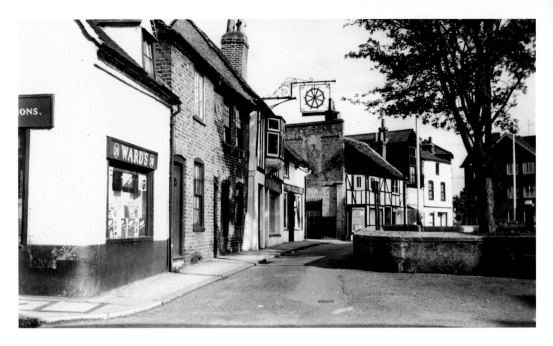

Cross Street

The street was a narrow shortcut between Windsor Street and Vine Street, and one of the most attractive parts of old Uxbridge. Despite protests it was all demolished, but the busy road here is still named Cross Street.

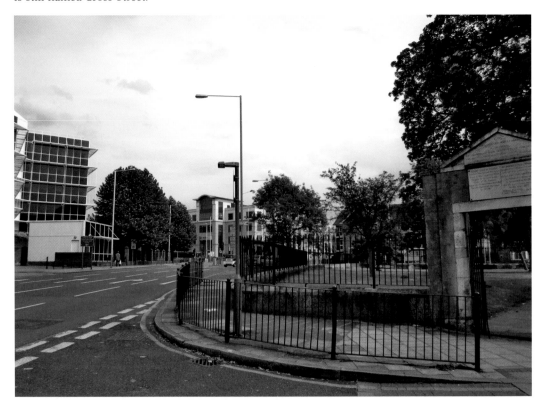

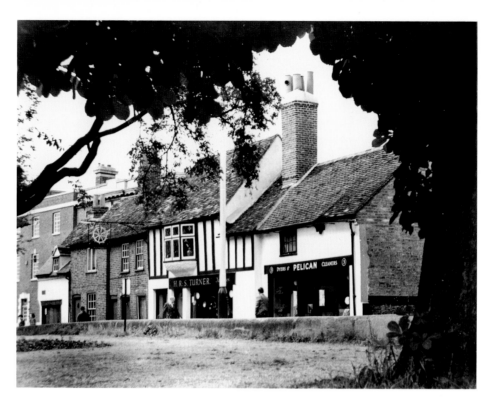

Cross Street
Some of the timber-framed buildings are shown here. One had been a public house called the Catherine Wheel, and the sign was retained after it became an antique shop. Clearance in 1969 exposed the old wooden framework.

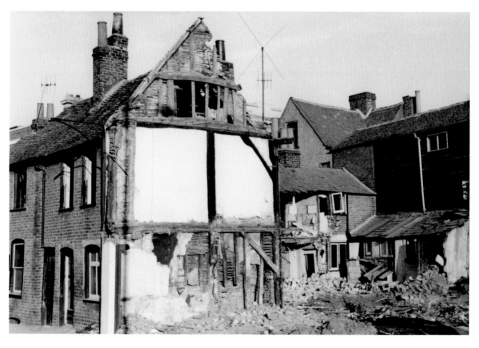

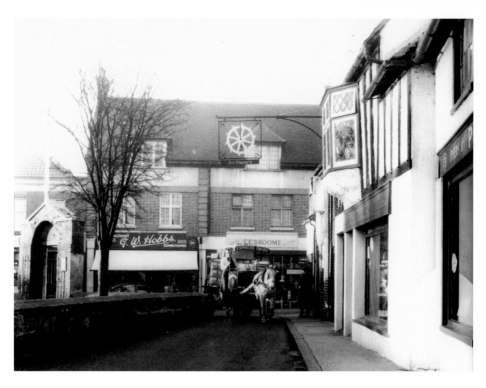

Milk Deliveries

Part way along Cross Street lay the depot of the Express Dairy from about 1933 to 1970, and here is one of their horse-drawn floats turning in from Windsor Street. Today Dairy Crest operates in electric-powered vehicles from a depot in Hillingdon.

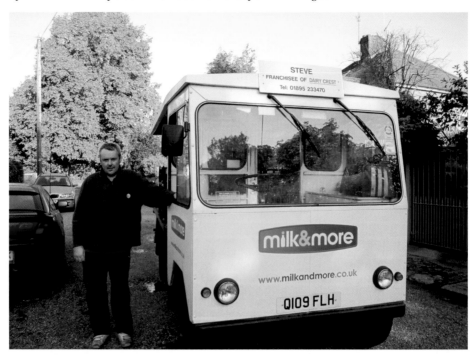

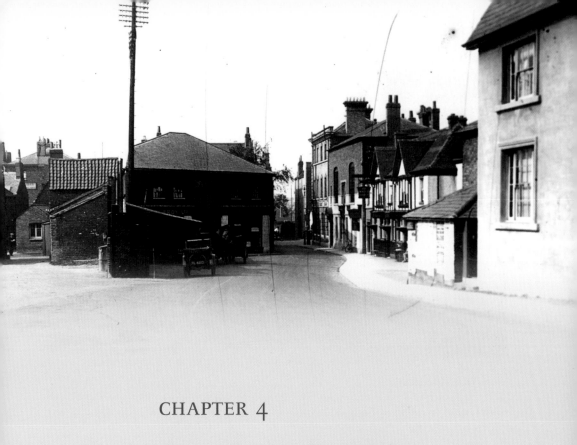

CHAPTER 4

North Uxbridge

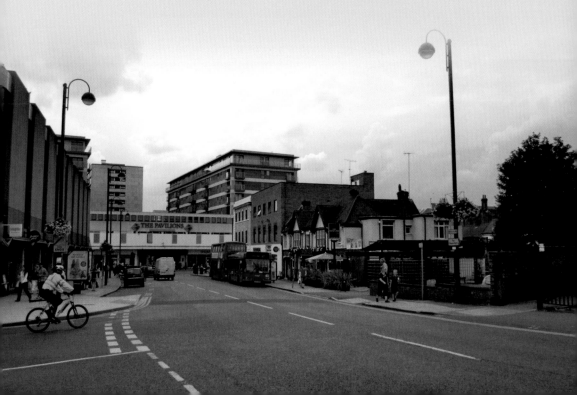

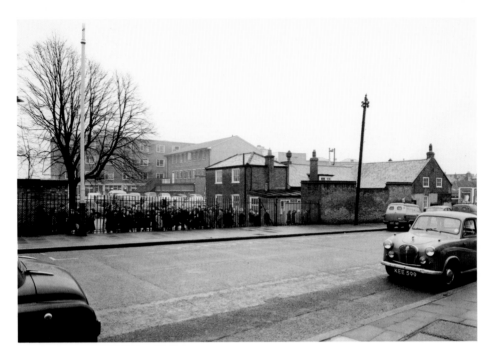

Belmont Road School

The school opened as a charity school for girls in 1816, became a council school in 1909, and an infants' school in 1928. It closed in 1968, when the pupils transferred to the new Hermitage School. The office block now on the site includes JobCentrePlus, a slick name for a Labour Exchange.

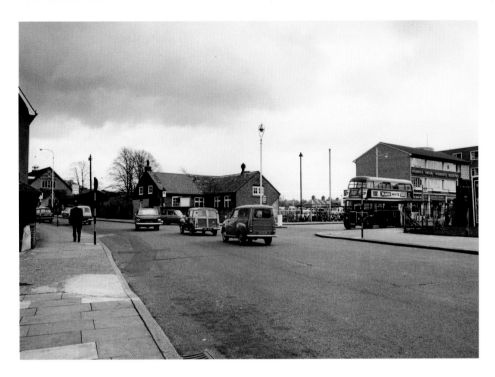

Bakers Road Junction
This view, dating from about 1960, shows the parish hall on the extreme left, and Belmont Road School in the centre. Bakers Road was first used as the town's bus station in September 1939.

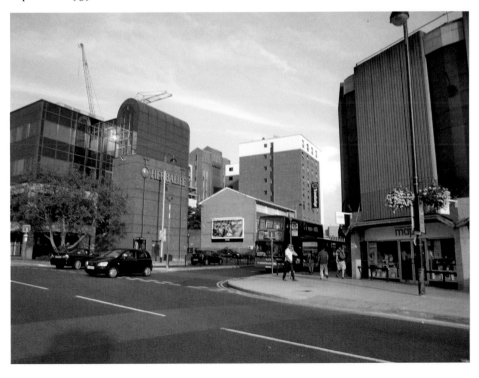

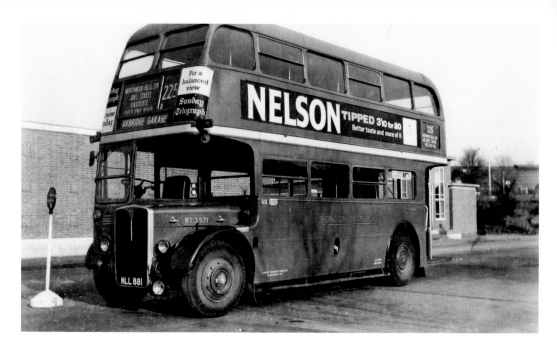

An RT Bus

This double-decker bus was photographed in Bakers Road in 1962. Behind it is a staff canteen used by bus and train employees, but this facility was lost when the Bakers Court development took place. Below is one of the latest vehicles, made by Volvo.

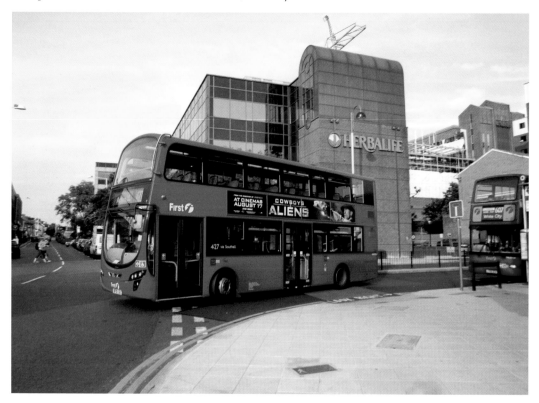

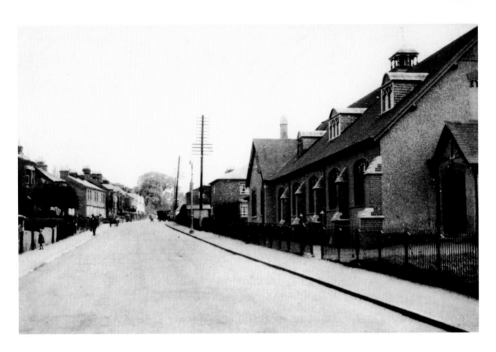

The Church Hall

St Margaret's hall, on the right, was opened in May 1908 and was used for many church and community activities. The RAF took over the building in the Second World War. The church sold the hall in 1986, and used some of the proceeds to re-order the interior of St Margaret's church. The Allied Irish Bank now occupies the site.

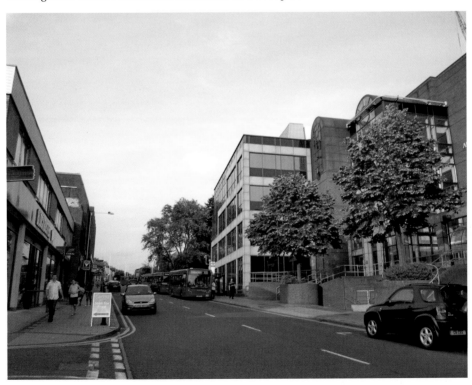

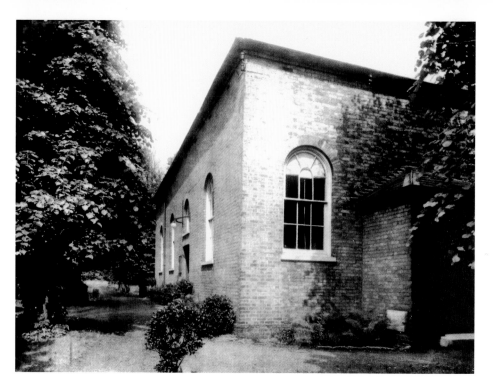

Friends' Meeting House

The origin of the Society of Friends, or Quakers, in Uxbridge has been traced to 1658, and their first meeting house on this site was built in 1692. The present building dates from 1818. In the eighteenth and nineteenth centuries the Quakers were prominent in the commercial life of Uxbridge.

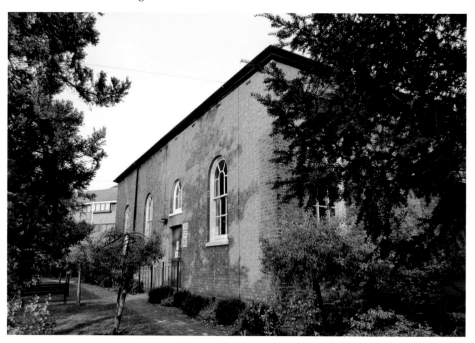

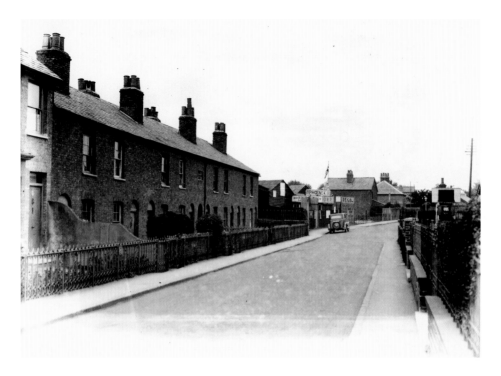

York Road

As this 1935 picture shows, York Road has been completely rebuilt. The cottages on the left were about to be demolished then, and everything else has followed. Sainsbury's supermarket and Bakers Court now dominate the street, the latter being refurbished to house the UK headquarters of Coca Cola.

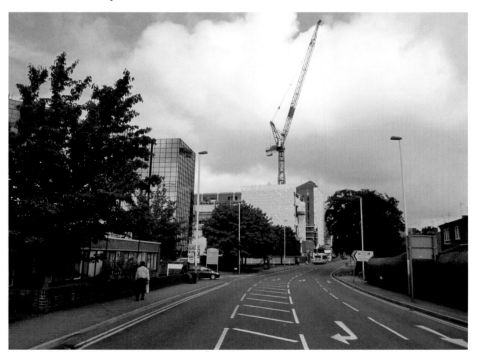

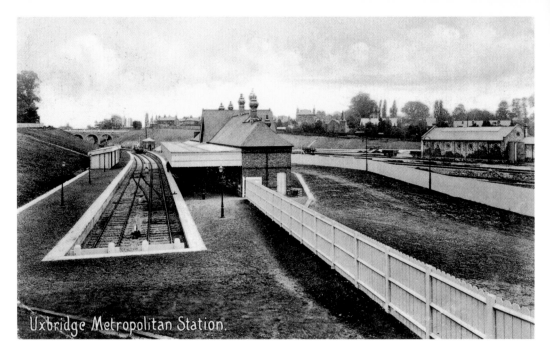

Uxbridge Metropolitan Station.

Metropolitan Station

The Harrow to Uxbridge section of the Metropolitan Railway was opened in June 1904, and this view from Belmont Road shows the station at that time. Piccadilly-line trains also came here in 1933 and in 1938 services moved to the present terminus. Today Sainsbury's car park fills the site.

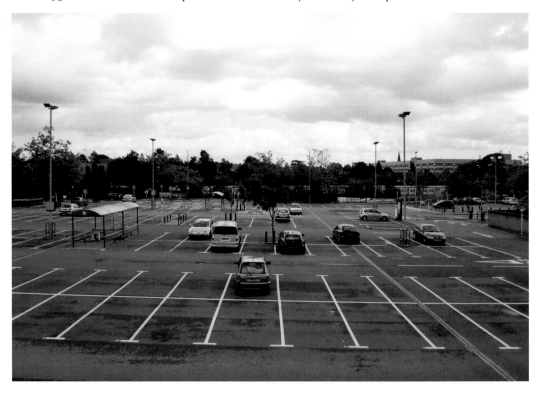

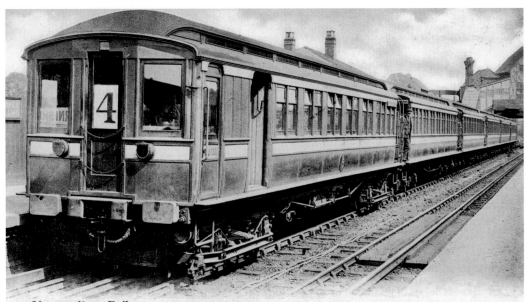

Metropolitan Railway, New Electric Train.

Knight Series No. 1630.

Electric Trains
One of the first electric trains to visit Uxbridge in the early years of the line. Below is one of the latest air-conditioned 'S' type units, introduced in 2010. Also in the York Road sidings are two 'A' stock trains introduced in 1960, and now being progressively replaced.

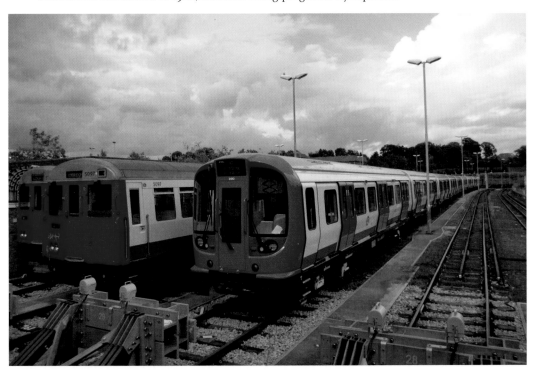

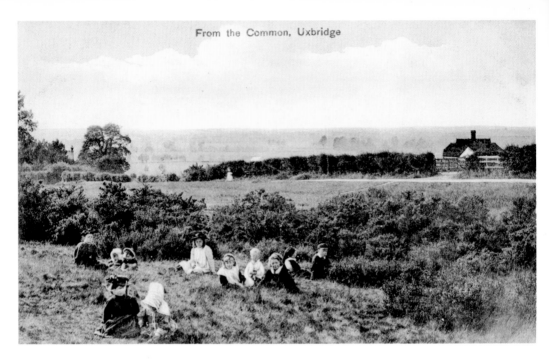

From the Common, Uxbridge

Uxbridge Common

The common was huge at one time, stretching as far as Northolt, but the 1825 Enclosure Award decreed that about 15 acres only should remain unenclosed. This is today's common. It has been maintained by the local council since 1898.

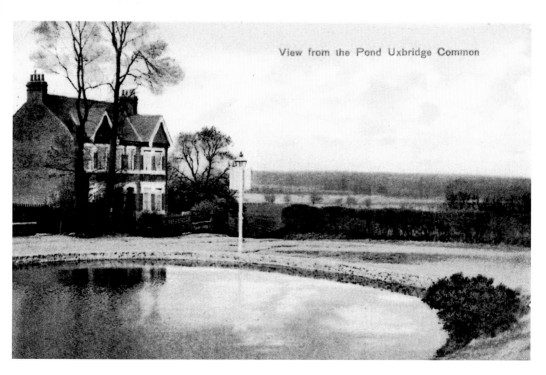

View from the Pond Uxbridge Common

Common Pond

The common is surrounded by ditches, and the water from these drains into the pond – treasured now as an environmental asset. It is surely unusual to have a pond at the top of a hill!

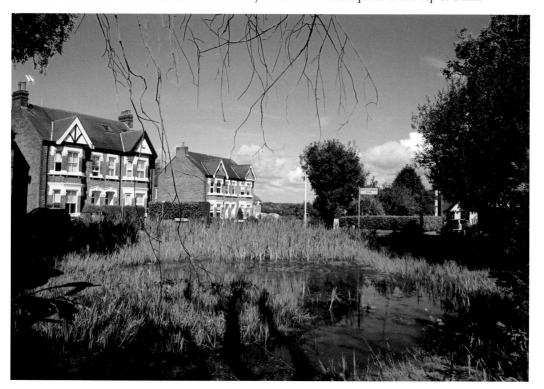

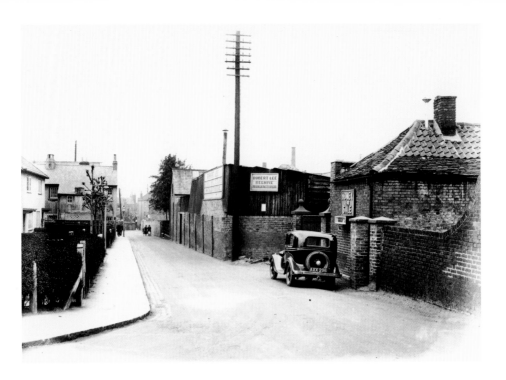

George Street

The buildings on the right were once an iron foundry, but from 1912 were occupied by Robert Lee Ltd., suppliers of beekeeping equipment. They left in 1981. Harman House, a glass-fronted office block opened in 1985, now towers over the scene.

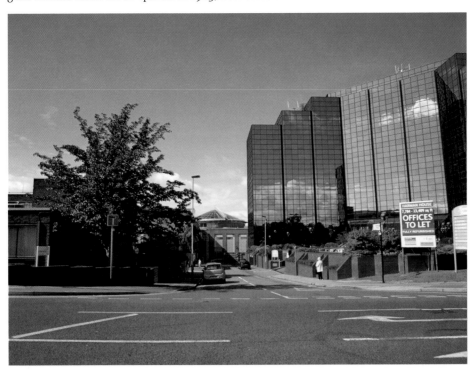

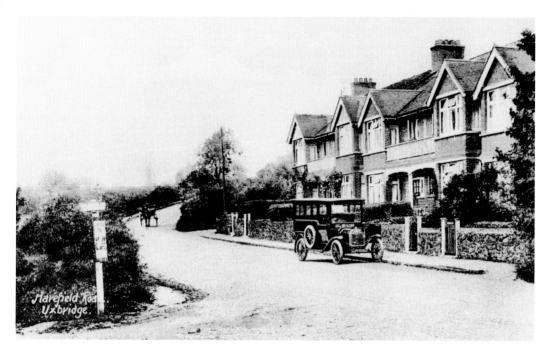

Harefield Road

The road was formerly called Pages Lane, but was renamed in 1871. The old name has been revived in a nearby modern housing development. The photograph above dates from about 1920.

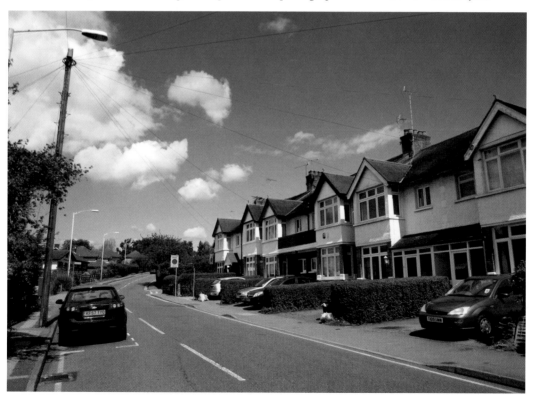

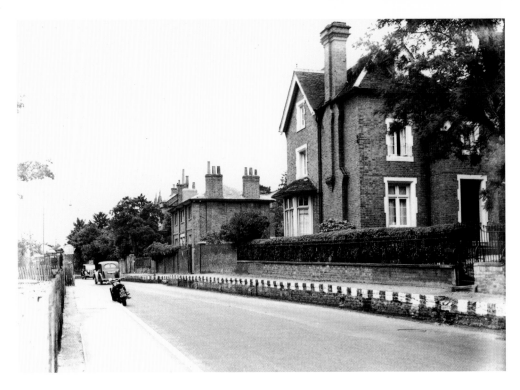

Harefield Road/High Street

In this 1939 scene the houses on the right, called Hertford Terrace, faced the magistrates' court across the road. Everything has changed, and in the lower picture the modern police station is on the right. It came into use in February 1988.

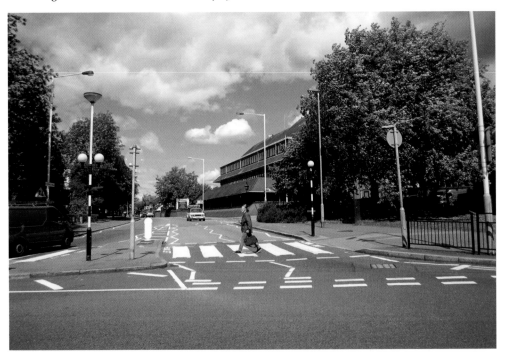

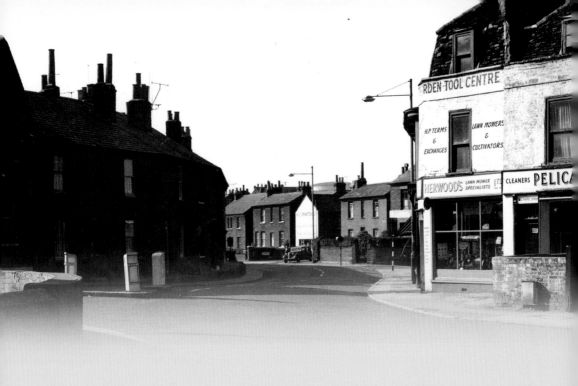

CHAPTER 5

South Uxbridge

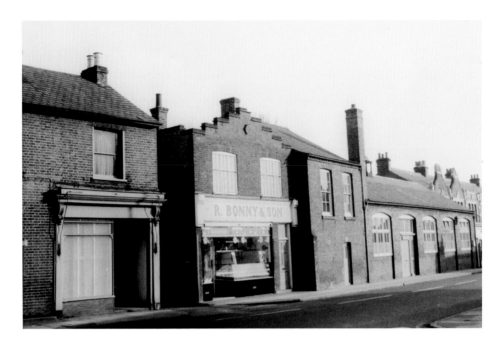

Shops and Canteen

This is part of Cowley Road in 1971. The school meals canteen on the right began life as Cowley Road Boys' School in 1835. The school closed in 1929, and for the next ten years the building housed Uxbridge Library. It then became a rest centre for the forces during the Second World War, and then a school meals canteen. A new headquarters for the Salvation Army opened here in 1974, and was enlarged in 2000.

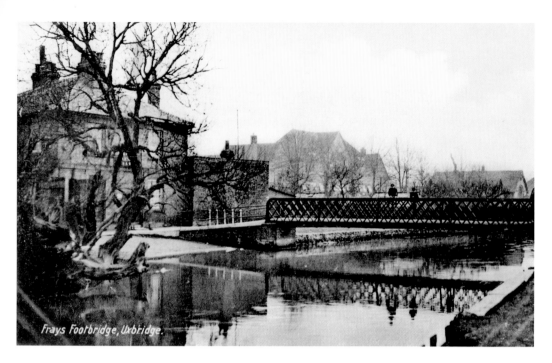

Frays Footbridge, Uxbridge.

The Van and Horses

This public house stood between Cowley Road and the Fray's River but road widening led to its closure and demolition in 1972. In both pictures the buildings of Whitehall School, opened in 1911, can be seen in the background.

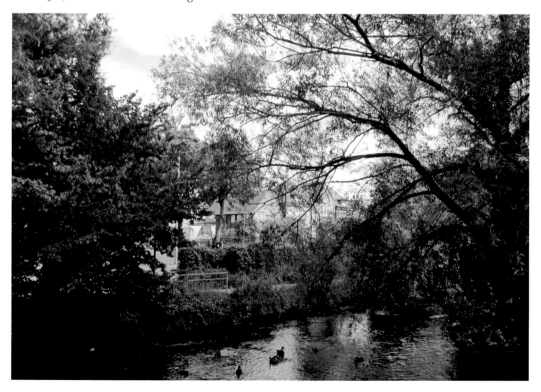

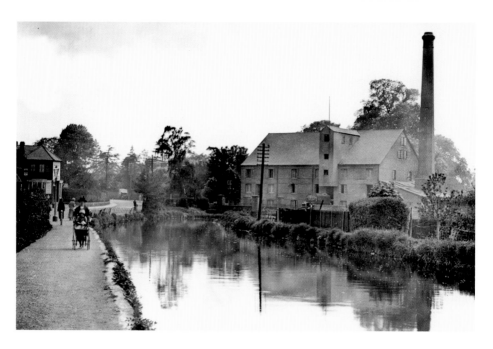

Cowley Mill

This former flour mill on the Fray's River was earlier known as Rabb's Mill, Austin's Mill and Dobell's Mill. An enormous fire in 1928 brought an end to the flour trade. The heat was so intense that it was claimed you could cook sausages on the nearby pavement! A small part of the old mill survives in the Hale Hamilton factory.

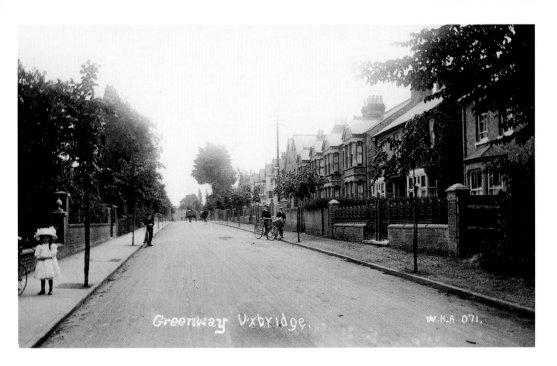

The Greenway

This early twentieth century postcard showing the western end of the Greenway reveals a wide, elegant highway bounded by substantial villas. This area was devastated in June 1944 by a Nazi V1 rocket or 'doodlebug'. Seven people were killed, and others injured. Traffic to nearby industrial estates now makes this a busy road.

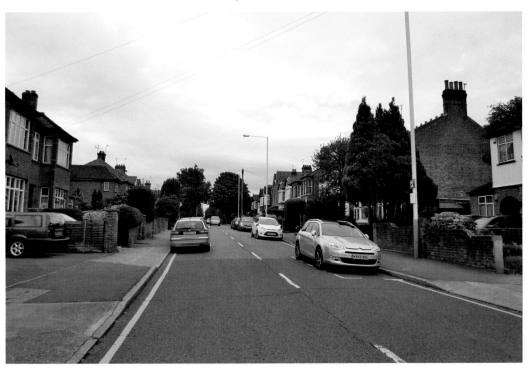

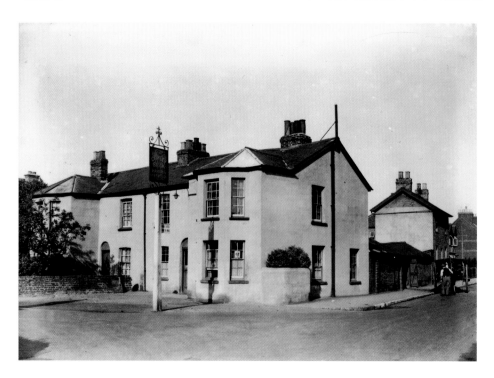

The Cowley Brick

In the late eighteenth century a brickworks opened off Whitehall Road, and this public house offered refreshment to the labourers. Like many other pubs it failed to survive modern changes and regulations and closed in 2010. Conversion to residential use followed.

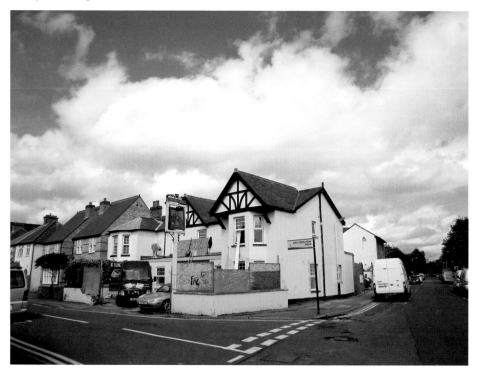

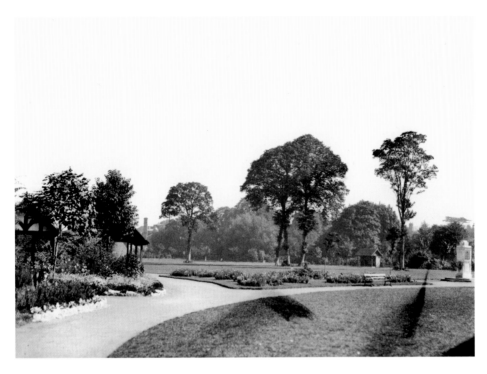

Fassnidge Recreation Ground

Thanks to the generosity of Mrs Kate Fassnidge, who gave most of the land to the town in memory of her husband, this recreation ground was ready in 1926. The drinking fountain on the right records the town's gratitude for the gift. Not shown here are the children's playground, bandstand and sports facilities.

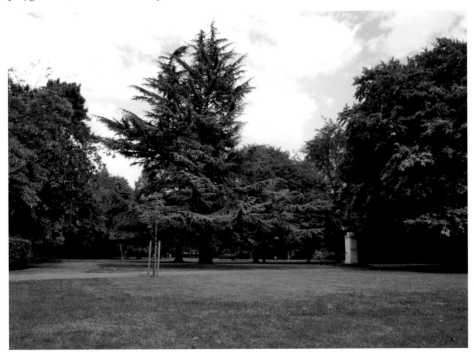

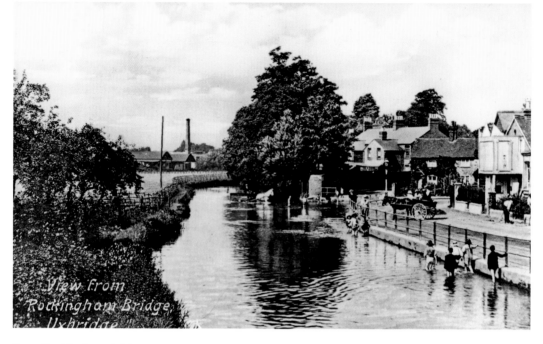

Near Rockingham Bridge

The top picture, dating from about 1910, shows a field on the left that was to become the Fassnidge Recreation Ground. The building on the extreme right was known as Rockingham Hall, and was the town's first cinema.

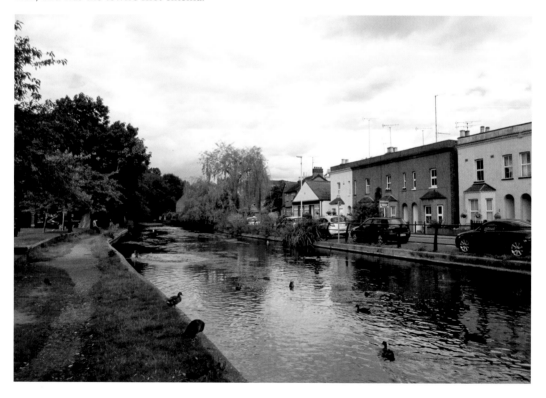

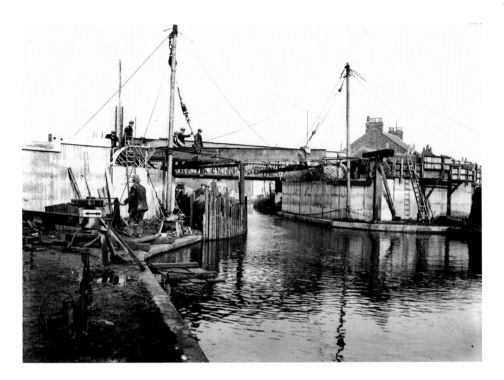

Dolphin Bridge

This canal bridge, adjacent to the Dolphin public house, was rebuilt in 1930. Increased traffic between the wars led to a great deal of road-widening and bridge-rebuilding. In the lower photograph the Second World War concrete pillbox is a solemn reminder of the threat of Nazi invasion in 1940.

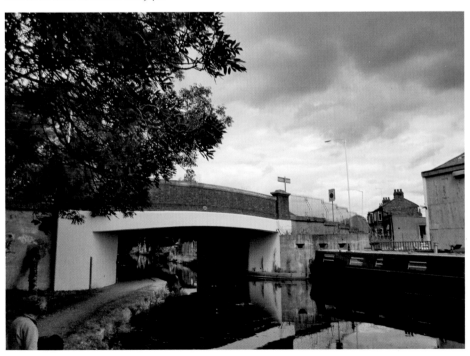

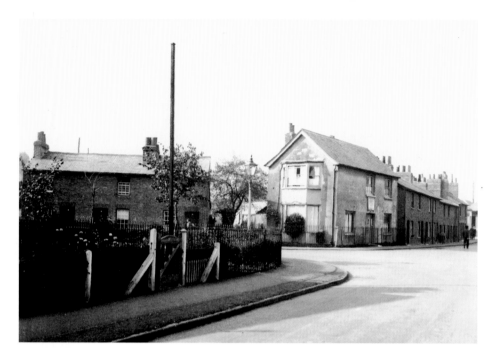

Ragged School

The house in the centre of the top picture became the home of Uxbridge Ragged School in 1846, a place where poor children gained some knowledge of the three Rs before the days of state education. The usual fee was a penny a week. This school led to the founding of Waterloo Road Church.